Images of Modern America

THE NATIONAL TRAINING CENTER AND FORT IRWIN

Front Cover: An M47 Dragon gunner and assistant gunner keep an eye on the armored vehicles moving across the valley below them during a live-fire exercise at the National Training Center. The soldiers, members of 1st Battalion, 505th Infantry Regiment, 82nd Airborne Division, are wearing Multiple Integrated Laser Engagement System (MILES) gear. (Department of Defense and the National Archives.)

Upper Back Cover: An M2 Bradley Fighting Vehicle and an M1 Abrams Tank maneuver during training exercises at the National Training Center and Fort Irwin. The National Training Center is the only installation in the United States that has the necessary land to allow the Army to conduct brigade-on-brigade training with armored vehicles. (Department of Defense and the National Archives.)

Lower Back Cover (from left to right): Two US Army (USA) 2nd Brigade Combat Team (BCT), 10th Mountain Division soldiers keep a sharp eye from their fighting position for other USA soldiers role-playing Iraqi insurgents during a simulated battle in Gahr Albai and Millawa Valley on one of the ranges at the National Training Center (NTC), Fort Irwin, California (CA), during Rotation 06-05, which is a training program conducted at the NTC to enhance a unit's desert war fighting skills for future deployments (Department of Defense and the National Archives); George Bruining Jr. mans an antiaircraft gun during training at the Mojave Anti-Aircraft Range in 1941 (Rodney J. Beckwith IV); An M113 armored personnel carrier being used as the command post for an XVIII Airborne Corps live-fire exercise overlooks a valley at the NTC. (Department of Defense and the National Archives.)

Images of Modern America

THE NATIONAL TRAINING CENTER AND FORT IRWIN

Kenneth W. Drylie

ARCADIA
PUBLISHING

Copyright © 2018 by Kenneth W. Drylie
ISBN 978-1-4671-2795-0

Published by Arcadia Publishing
Charleston, South Carolina

Printed in the United States of America

Library of Congress Control Number: 2017945933

For all general information, please contact Arcadia Publishing:
Telephone 843-853-2070
Fax 843-853-0044
E-mail sales@arcadiapublishing.com
For customer service and orders:
Toll-Free 1-888-313-2665

Visit us on the Internet at www.arcadiapublishing.com

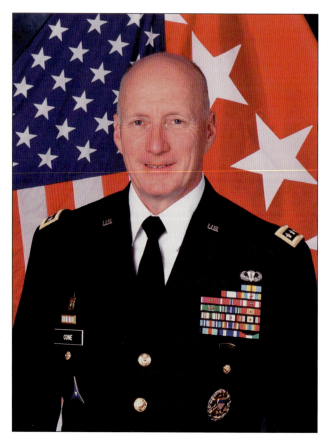

Dedicated to Gen. Robert Cone (March 15, 1957–September 19, 2016), the 15th commander of the National Training Center and Fort Irwin, from September 2004 to June 2007. (US Army photograph.)

Contents

Acknowledgments		6
Introduction		7
1.	The Early Years	11
2.	Camp Irwin Becomes a Fort	21
3.	The Guard Takes Over	31
4.	The National Training Center	39
5.	9/11 and Beyond	67
6.	Political Figures and Hollywood Visitors	75

ACKNOWLEDGMENTS

Many of the images in this work are the product of the hard work of US Army public affairs professionals; however, to really understand life during the early days of the National Training Center, several individuals have graciously allowed images from their personal collections to be included.

Special thanks go to the following:

Ray and Irene Bandziulis supplied photographs from Vytautas Bandziulis, Ray's father. The elder Bandziulis was a tank trainer at Fort Irwin in the 1950s. Some of his experiences were shared by Ray's wife, Irene, in the blog *Amber Reunion*.

Rodney J. Beckwith IV shared the experiences of George Bruining Jr. and his time at the Mojave Anti-Aircraft Range and Camp Haan, in Riverside, California.

Bob Wood from NASA Goldstone and Colin MacKeller shared the photographs of Walter Cronkite at Goldstone in the 1960s.

The 11th ACR and Fort Irwin Museum opened up their collection and allowed images of life at Fort Irwin to be shared.

Casey Slusser and Kevin Teal from the Training Support Division provided assistance by scanning way more 35-millimeter slides than were actually needed for the book.

Unless otherwise noted, all images appear courtesy of the Department of Defense and the National Archives.

Introduction

At first glance, the Mojave Desert does not look like much. Most travelers see it out the window as they blast through in their air-conditioned cars, heading for Las Vegas, Laughlin, or other points east of the desert. To the casual observer, it is a vast wasteland—desolate and uninviting.

The truth is that the desert is full of life, and man has occupied this challenging landscape for thousands of years. Animal life is abundant, just not easy to see. Rabbits, squirrels, birds, and other small animals inhabit the desert floor, perfectly camouflaged to protect them from roving predators. Bighorn sheep occupy the steep edges of the volcanic mountains rising above the sizzling sands. Burros and wild horses, descended from those left behind in the days of the old west, still roam free. Mountain lions, bobcats, and coyotes watch for the old or weak, while birds of prey circle, each looking for the next meal.

When man first wandered into the Mojave, the landscape was much different. Pleistocene lakes, now just dry lake beds, still filled at least seasonally, providing much-needed water for native camps. For thousands of years, Native Americans flourished throughout California, even in the harsh environment of the Mojave.

The first European known to pass through the Mojave was Fr. Francisco Garcés in 1776. After leading Capt. Juan Bautista de Anza and his expedition from Rio San Miguel, Mexico, to the Colorado River along the Gila River, Garcés left the expedition in December 1775 and wandered north and west into the Mojave Desert. De Anza would continue to Monterey and San Francisco. Garcés would stop in the area now known as Bitter Springs on his way through the Cajon Pass, finding a new path to Los Angeles. Other early visitors to the Bitter Springs area were Capt. John Frémont and Kit Carson. Frémont established a camp in the area that would be used by travelers along the Old Spanish and Mormon Trails.

Bitter Springs became an important stop for travelers through the Mojave Desert. Mountain man Jedediah Smith passed through the area while searching for a legendary river. Father Garcés, in his earlier trips into Alta California, believed the San Joaquin River originated over the Sierra Nevada in the Great Basin. This belief, along with a mistake by cartographers at the time, reinforced the belief by mountain men and trappers that there was a river that flowed from the Great Salt Lake to San Francisco. In 1826, Smith used Bitter Springs as a campsite on his way to Los Angeles. He returned again in 1827 before heading north to search for the river.

At the end of the Mexican War, a small group of soldiers who had once been part of the Mormon Battalion remained in California and were assigned to patrol the area from San Diego to Los Angeles and surrounding areas. In 1848, thirty-five Mormon volunteers headed home to Salt Lake City. They camped at the site of a spring. A member of the party, Jefferson Hunt, noted the alkali in the water on his map, calling it Bitter Spring. The name stuck.

James Marshall's discovery of gold at Sutter's Mill began an influx of treasure-seekers to California. Although most went north to the goldfields in the Serra Nevada, some of the forty-niners set up camp in the Fort Irwin area.

In June 1857, Edward Fitzgerald Beale, a former superintendent of Indian affairs for California and Nevada, who also held the rank of brigadier general in the California militia, started out on a surveying expedition to establish a roadway to connect the eastern territories with the far western territories. Only after winning the contract did the Army inform Beale that he would be required to use camels as part of his expedition.

The Army had imported camels from the Middle East to the southwestern United States to test the ability of the camel to transport goods in the harsh environment of the area. The experiment began in 1855 when the US Congress approved $30,000 for the War Department in "the purchase and importation of camels and dromedaries to be employed for military purposes." The early tests proved that camels were far superior to horses and mules for hauling large loads, especially in the deserts of the Southwest. Beale argued against using the animals, but he was told that he had no choice but to take them along.

On June 25, 1857, the surveying expedition departed for Fort Defiance. The party consisted of 25 camels, 2 drovers, 44 soldiers, 12 wagons, and some 95 dogs, horses, and mules. At first the camels moved rather slowly, and Beale was certain that bringing them along was a mistake. By the second week of the journey, the camels began to outperform the other animals and Beale began to see the advantages of the beasts. Beale and the camel expedition passed through the Fort Irwin area on their way to Fort Tejon. In his final report of the expedition, Beale provided a glowing appraisal of the use of camels in military operations.

The Army experiment came to an end as the Civil War was beginning, and Congress would not approve further funding. The Army auctioned off the camels, with some going to private individuals and several ending up in circuses. The last of the Army camels, Topsy, died in Griffith Park in Los Angeles in 1934.

One of the most ambitious undertakings of the 1870s was the Wheeler Survey, officially "the US Geological Survey West of the 100th Meridian." Lt. George Wheeler estimated that it would be a 15-year project. The goal was to map the entire western United States at a scale of eight miles to one inch. Wheeler believed that quality maps would aid in the settlement of the West by showing where roads, settlements, railroads, dams, and agriculture could exist.

One of Wheeler's early expeditions examined Death Valley, looking for a passage across the dangerous expanse and attempting to locate vital water sources in the area. Wheeler's team reported that the nighttime temperature at its Furnace Creek campsite was 109 degrees.

Traveling with Wheeler was photographer Timothy O'Sullivan, who started his career working with Mathew Brady prior to the Civil War. O'Sullivan would gain a measure of fame from his photographs of the Civil War. Wheeler produced many photographs during the expedition, but many were lost when the expedition's boats overturned in the Colorado River.

Wheeler would eventually create the first accurate topographical maps of the Fort Irwin area. The Wheeler expedition was one of four extensive surveys being conducted simultaneously by the US Army. Congress felt that the surveys were duplicating efforts and combined them into one organization, the US Geological Survey.

In 1881, borax was discovered in Death Valley by Rosie and Aaron Winters. Large borax smelting plants were established in the valley—creating borax soap and for industrial uses. The finished product had to be moved by wagon to the railhead in either Mojave or Daggett. The borax was transported by 20-mule-team wagons (actually made up of 18 mules and two horses) designed to move nine tons of ore at a time. With teams hitched to the wagon, the total length of the vehicle was over 180 feet. On the Daggett run, the team would leave Death Valley via Cave Springs, travel around Bicycle Lake, and head toward town along what is now the Mannix Tank Trail.

In 1908, a similar path was taken by Antonio Scarfoglio when he passed through the area during the New York–to–Paris automobile race in 1908. Scarfoglio, the driver of the Italian Zust car, was the only one of the four cars remaining in the race to take a southern route out of Death Valley. After pausing at Stove Pipe well, the lead car, the American Thomas Flyer, headed south, cut through the Panamint Mountains, and went past Tehachapi on the way to San Francisco, the next major checkpoint. The next cars followed a similar path.

The Zust car chose to drive south, over Cave Spring and into Daggett, where the team members spent the night. The following day, they drove what would later become Route 66, from Daggett down the Cajon Pass into San Bernardino. From San Bernardino, they headed into Los Angeles, where they received a hero's welcome and celebration at the Italian Club in downtown Los Angeles. The Thomas eventually won the race after the German Probst automobile received a time penalty for shipping a car partway by rail.

Mining returned to the area in the early 1900s, and in 1909, the town of Goldstone sprang from the desert floor. The mines in Goldstone remained in operation until the mid-1930s. Some of the more colorful miners who occupied the area of Fort Irwin were John Lemoigne and Adrian Egbert. Egbert moved into the Cave Spring area in 1925, creating a small fuel and supply shop in one of the caves in the area.

At the time, Cave Spring was the main entrance into Death Valley and was a fairly well traveled but difficult road. Egbert met a wealthy widow, Ira Sweatman, who became his business partner. Egbert built several buildings at Cave Spring. He spent his time prospecting or running the service station and began to place food and water along the route from Daggett to Death Valley. Egbert received a visit from famed author Ernie Pyle, who was on his way to Death Valley to meet Death Valley Scotty. Pyle was working for Scripps-Howard newspapers, traveling the country writing about Americans—some famous, some just regular people. Pyle's stories were published in the book *Home Country* after his death in World War II. The story of his night in Cave Springs is included in the book.

John Lemoigne is something of a mystery. A tall, well-educated Frenchman, he became a well-liked member of the desert mining community. One story has it that Lemoigne had grub-staked a couple of fellow miners, who started to make a good bit of money. They began making payments to Lemoigne, who, preferring a simple lifestyle, was somewhat distressed by his new wealth. Not trusting banks, he persuaded a local merchant to hold his funds at the store in Daggett. As the amount of cash grew, the shopkeeper began to worry that bandits or the railroad workers in nearby Barstow might get word of the large amounts of cash in his store. The shopkeeper's wife convinced Lemoigne that he should allow her to build him a large house at his Garlic Springs site. He agreed and construction began on what would be known as the Lemoigne Castle. The building was described as a large, two-story, square building with turrets, a spire, and dormer windows. A covered porch surrounded the bright red structure on all four sides, and the building sported green-trimmed windows with blue shutters. Lemoigne found the building and the heavy oak furnishings inside to be a bit more than what a simple miner required. So he did what any good miner would do: filled it with dynamite and blew the building and its contents into dust.

The mining years were coming to an end in the area—not that the mines had dried up, but the US Army was looking for an area where it could train soldiers on large weapon systems; this was found in the middle of the Mojave Desert.

One

THE EARLY YEARS

On August 8, 1940, Pres. Franklin D. Roosevelt signed legislation creating the Mojave Anti-Aircraft Range (MAAR) on 1,000 acres of desolate terrain in the Mojave Desert, chosen for the remote location that allowed the Army to train on the weapons that would become the first line of defense during the coming war. The installation was a subsidiary of Camp Haan in Riverside, California, next to what is now March Reserve Air Field.

The trip up the Cajon Pass to MAAR was not a pleasant one. As vehicles crossed into the desert, the heat would become almost unbearable, but it got worse by the time the soldiers off-loaded in the High Mojave. "It had been hot riding in the truck, but when we jumped out into the glaring sunlight, it felt like we were entering a blast furnace. We all stood there a few minutes with nobody talking. It was as if we had landed on another planet, and nobody could find words to describe it or even to damn it," notes Robert F. Gallagher in "Scratch One Messerschmitt," a World War II story. Life at MAAR was tough. Soldiers lived six men to a tent, the sand-colored canvas blending into the forbidding landscape.

In 1942, the reservation received its official name, Camp Irwin, in memory of Maj. Gen. George LeRoy Irwin, World War I commander of the 57th Field Artillery Brigade. In 1944, the camp was deactivated. In 1951, the camp was reactivated and became the US Army Armor and Desert Training Center, preparing soldiers for the war in Korea. Life was a little better in the 1950s. More permanent facilities had been built, the sand-colored tents giving way to rows of white wooden barracks.

Things at the remote post continued to improve, more permanent facilities were built, and little by little, the desert camp became home for the soldiers (along with their families) who would train the nation's armed forces.

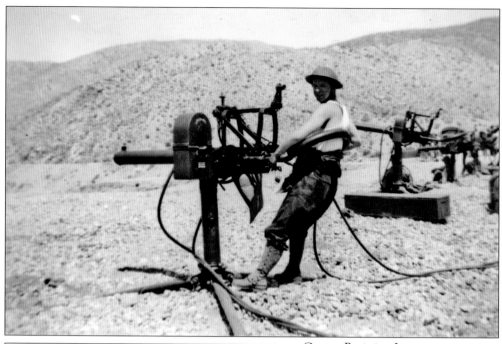

George Bruining Jr. mans an antiaircraft gun during training at the Mojave Anti-Aircraft Range in 1941. (Courtesy of Rodney J. Beckwith IV.)

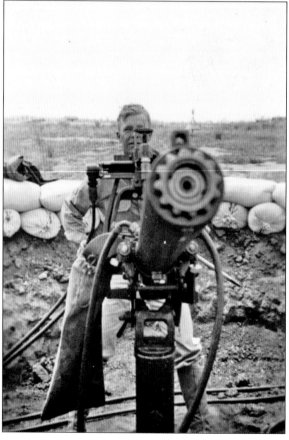

George Bruining Jr. shows the camera the business end of a .50-caliber antiaircraft gun. (Courtesy of Rodney J. Beckwith IV.)

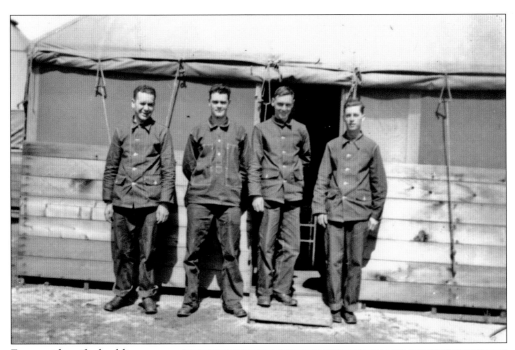

Four unidentified soldiers pose outside their living quarters at MAAR in the early 1940s. They are wearing blue denim field uniforms instead of the usual Army fatigues. (Courtesy of Rodney J. Beckwith IV.)

Fort Irwin is named for Maj. Gen. George LeRoy Irwin, commander of the 57th Field Artillery Brigade during the Second Battle of the Marne, Oise-Aisne Offensive, and Meuse-Argonne Offensive. At the time, the 57th was part of the 32nd Division, commanded by Maj. Gen. William G. Haan. When Camp Irwin was named, it was a subordinate base of Camp Haan in Riverside, California, and used as an artillery range. (US Army photograph.)

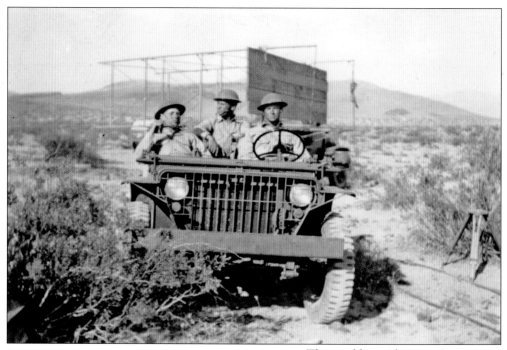

Three soldiers ride in an Army quarter-ton 4x4 utility vehicle near the obstacle course at MAAR. The vehicle is a Ford Pygmy version of the Willys jeep. (Courtesy of Rodney J. Beckwith IV.)

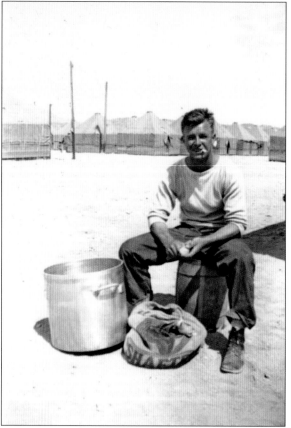

George Bruining Jr. pauses while peeling potatoes during kitchen police (KP) duty at MAAR. Peeling potatoes was the bane of existence of many GIs on KP. (Courtesy of Rodney J. Beckwith IV.)

The launch rack for the Private A and Private F missiles fired at Camp Irwin in December 1944 is seen here. The Private series of missiles were the first two-stage rockets fired by the United States. They marked the beginning of what would become the US space program. (US Army photograph.)

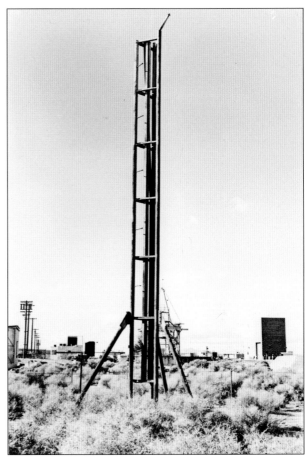

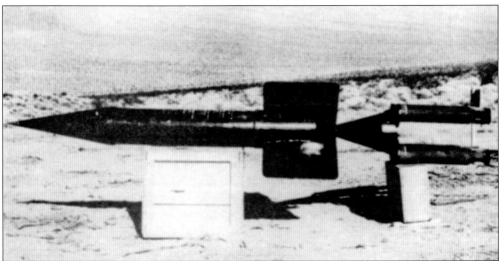

The Private A rocket is pictured at Leach Lake in Camp Irwin. The Private was the first in a series of rockets tested at Fort Irwin in December 1944 by the Guggenheim Aeronautical Laboratory at the California Institute of Technology (GALCIT). In 1945, the GALCIT group adopted the name Jet Propulsion Laboratory. (US Army photograph.)

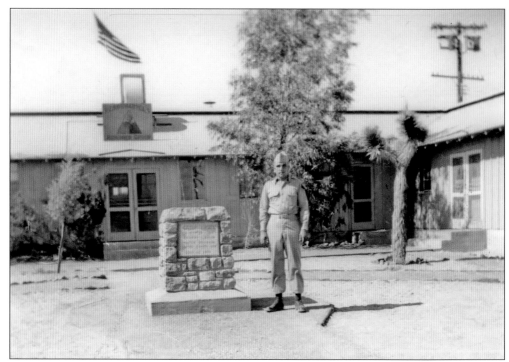

Vytautas Bandziulis poses in front of the headquarters of the US Army Armor and Desert Training Area (AADTA) in 1951. Bandziulis came to the United States as a displaced person after the Soviet takeover of Lithuania. (Courtesy of Ray and Irene Bandziulis.)

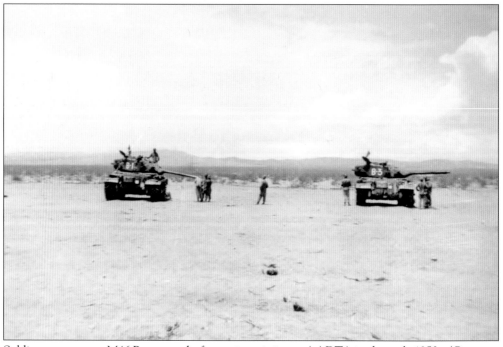

Soldiers prepare two M46 Patton tanks for use in training at AADTA in the early 1950s. (Courtesy of Ray and Irene Bandziulis.)

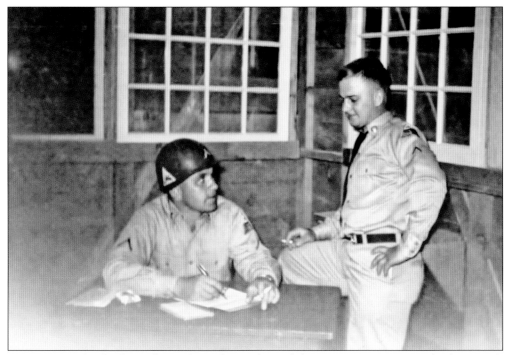

Vytautas Bandziulis (seated) speaks with another solider at Camp Irwin. Bandziulis, a tank instructor at AADTA, is wearing a helmet with the rank of corporal, but his uniform indicates the rank of private. As an instructor, he was considered to have the authority and privilege of the higher rank. (Courtesy of Ray and Irene Bandziulis.)

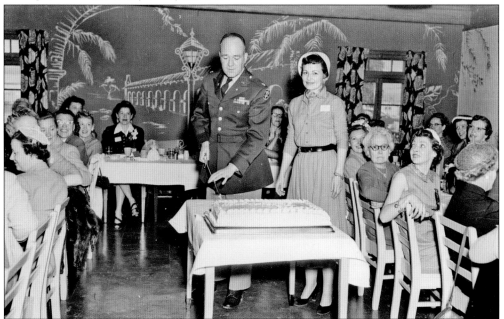

Post commander Col. Eugene McDowell cuts a cake celebrating the second anniversary of the Officers Wives Club (OWC) on March 3, 1955. Also pictured is Grace Boccieri, OWC president. (Courtesy of the 11th Armored Cavalry and Fort Irwin Museum.)

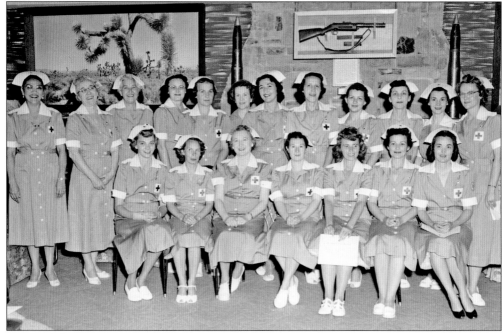

Wives of the officers of Camp Irwin pose at a "Capping Ceremony" for volunteers at the post hospital in 1956. The volunteers are known as the Grey Ladies, after their grey uniforms. (Courtesy of the 11th Armored Cavalry and Fort Irwin Museum.)

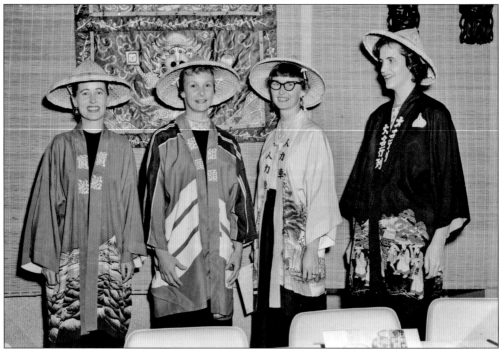

Hostesses for the November 1959 luncheon of the OWC, Helen Chambers, Clair Brown, Martha Smith, and Joyce Remsen pose wearing kimonos and coolie hats celebrating the Chinese theme of the lunch. (Courtesy of the 11th Armored Cavalry and Fort Irwin Museum.)

An unidentified chef poses with Thanksgiving dinner at the AADTA enlisted mess in 1951. (Courtesy of Ray and Irene Bandziulis.)

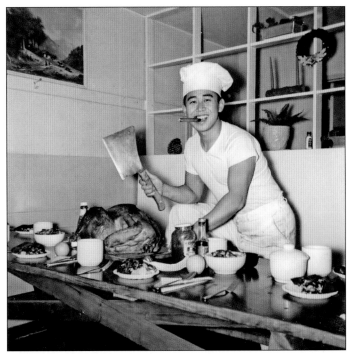

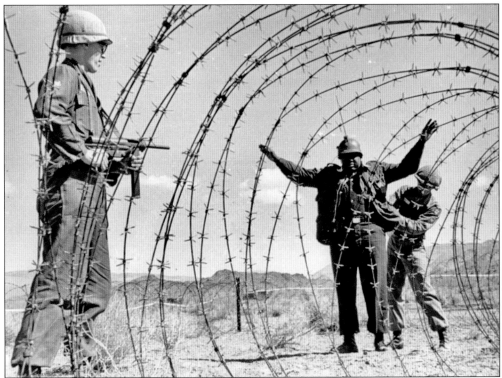

Soldiers of the 32nd Infantry "Red Arrow" Brigade prepare for deployment to Germany as part of the response to the Berlin crisis. The exercise, called Bristlecone Pine, took place entirely on Fort Irwin. (US Army photograph, 32nd Infantry Brigade Public Affairs Office.)

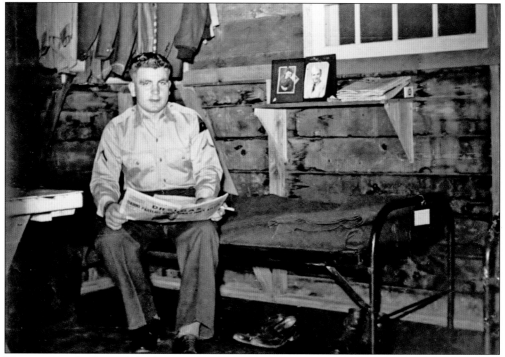

Vytautas Bandziulis reads his hometown newspaper while sitting on his bed in his quarters at Fort Irwin in 1952. Living conditions during the 1950s were very basic. The tents of the 1940s had given way to wood-sided huts that rested on concrete blocks. (Courtesy of Ray and Irene Bandziulis.)

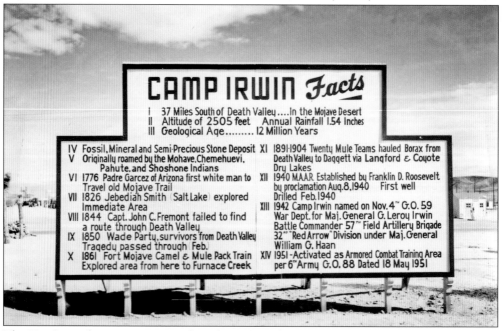

The Fort Irwin facts sign is pictured in the 1950s. The sign, or versions of it, was first located on post and was later moved 31 miles to the highway near Barstow, then eventually attached to Chuckwalla Gym. (Courtesy of Ray and Irene Bandziulis.)

Two

Camp Irwin Becomes a Fort

Until the 1960s, the US Army presence in the Mojave Desert was considered a temporary solution. The Mojave Anti-Aircraft Range and the Army Armor and Desert Training Center (AADTC) were used by soldiers stationed at Camp Haan for training on crew-served weapons, artillery, and armored vehicles.

The Army was preparing for the worst, the possibility of open conflict with communist forces in Europe. It was apparent that the AADTC was going to be needed for a long time. After operating as a temporary facility since 1941, Camp Irwin became a permanent US Army facility on August 1, 1961, and the name was changed to Fort Irwin. "This training mecca for tankers presents a cross section of terrain that offers a sample of every natural topographical feature to be found in the battle fields of the world," stated the 1960 *Fort Irwin Guidebook*. "The rugged land consists of flat desert abruptly rising to steep mountains, extreme temperature readings between 130 and 25 degrees, all in all a formidable testing ground for the metal of armor and the mettle of man."

The possibility of armed conflict escalating to the deployment of nuclear weapons led the Army to conduct a large-scale training mission called Exercise Desert Strike. This, the largest joint service exercise since World War II, began with the "invasion" of the fictional country of Calonia, which stretched from the Colorado River to the Pacific Ocean, by the fictional country of Nezona, which reached from the Colorado River to Texas. The exercise involved over 100,000 men, 7,000 vehicles, 1,000 tanks, and over 800 aircraft, and took place in a battle space over one quarter of the United States. The 2nd Brigade, 40th Armored Division, part of Task Force Mojave, drew all its equipment from the Fort Irwin Con-Site. Fort Irwin also supported the units of the active Army with logistics and repair support. After the dust settled, it took the mechanics of Fort Irwin over eight months to recover all the disabled vehicles.

Mrs. Owens, Mrs. Lippert, Mrs. Taylor, and Mrs. Troutman are welcomed to Fort Irwin by the OWC at their monthly luncheon. The theme was the "Poor Man's Lunch." (Courtesy of the 11th Armored Cavalry and Fort Irwin Museum.)

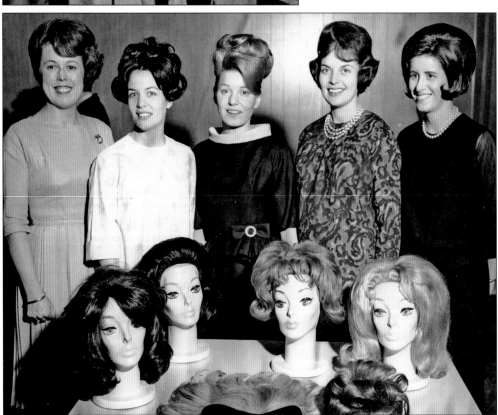

Jackie Russell, Ann Keough, Judy Cheesbro, Betsy Northup, and Sandy Trotter pose with their winning wig designs during the January 1964 luncheon of the OWC. (Courtesy of the 11th Armored Cavalry and Fort Irwin Museum.)

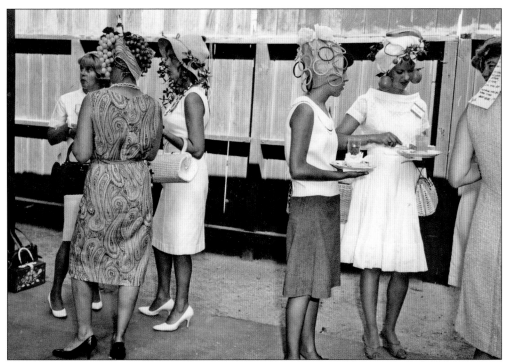

Members of the OWC balance lunch plates and drinks at the Crazy Hat–themed October 1966 lunch meeting. (Courtesy of the 11th Armored Cavalry and Fort Irwin Museum.)

Lunch committee members Martha Marx, Molly Mercer, and Pat Tarelton pose in front of the fireplace in the Officers' Club before the March lunch meeting of the OWC. (Courtesy of the 11th Armored Cavalry and Fort Irwin Museum.)

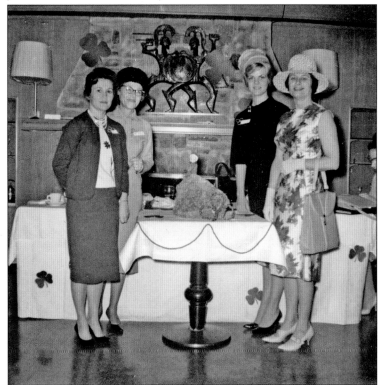

Legendary broadcaster Walter Cronkite rides in the back of a Jet Propulsion Laboratory jeep near the Goldstone Ghost Town in Fort Irwin's western training area on July 4, 1969. Cronkite was filming the final segment on the preparations for the Apollo 11 mission. (Photograph by Bob Wood NASA Goldstone, courtesy of Colin MacKeller.)

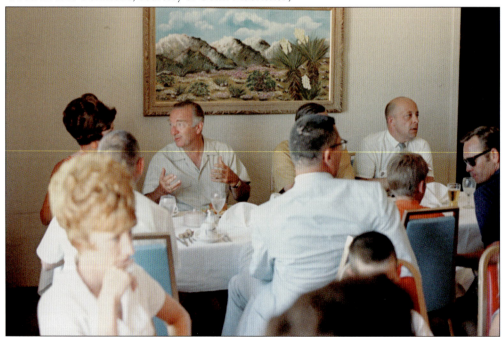

Walter Cronkite and members of NASA's Jet Propulsion Laboratory have lunch in the Fort Irwin Officers' Club on July 4, 1969. Cronkite was at Fort Irwin to film a story on JPL's Goldstone Deep Space Tracking Station. The segment aired July 15, the night before Neil A. Armstrong, Michael Collins, and Edwin E. "Buzz" Aldrin Jr. launched for the first moon landing. (Photograph by Bob Wood NASA Goldstone, Courtesy of Colin MacKeller.)

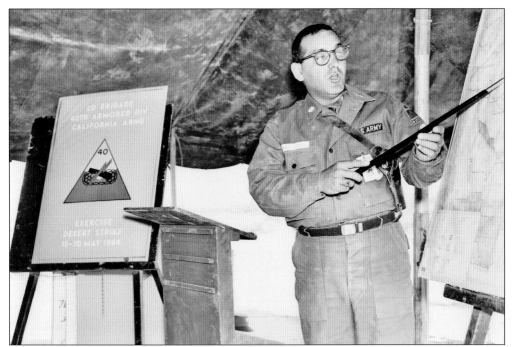

Maj. Anthony L. Palumbo, 2nd Brigade, 40th Armored Division of the California Army National Guard, briefs during Exercise Desert Strike in May 1964. Palumbo later became the commanding general of the 40th Infantry Division. He also served on the Governor's Select Committee on Law Enforcement Problems in 1972–1973 for Gov. Ronald Reagan.

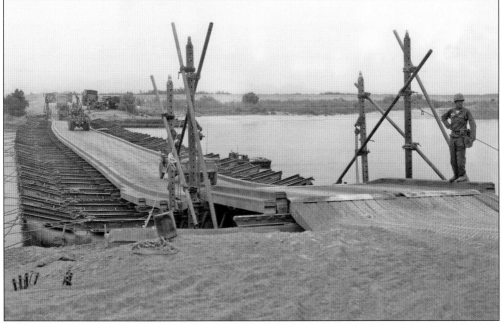

Soldiers perform a crossing of the Colorado River at the beginning of Exercise Desert Strike. The exercise was the largest conducted by US troops since World War II. The simulated war game began when the fictional country of Calonia was invaded by its neighbor Nezona.

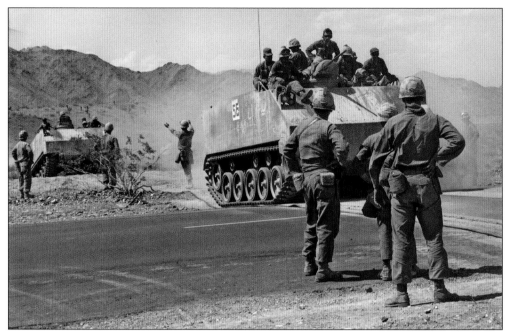

Soldiers observe an M113 armored personnel carrier cross a civilian road during Exercise Desert Strike. Although most of the maneuvering was done in open desert, civilian roadways still needed to be crossed by the armored vehicles. Protective mats were placed over the asphalt roadway to protect the road from the tracks of the armored vehicles.

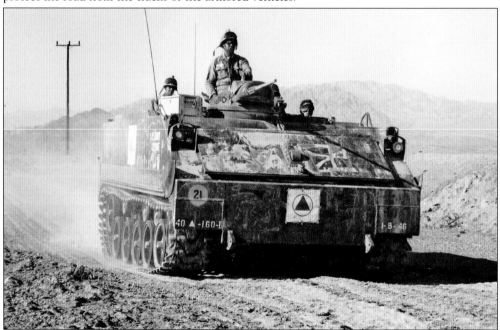

An M113 armored personnel carrier from the 40th Armored Division drives down a dirt road during Exercise Desert Strike. The vehicle has the green triangle and circle insignia of the Trigon Party, a fictional force used to designate soldiers assigned to the "Aggressor Force" during Army training exercises.

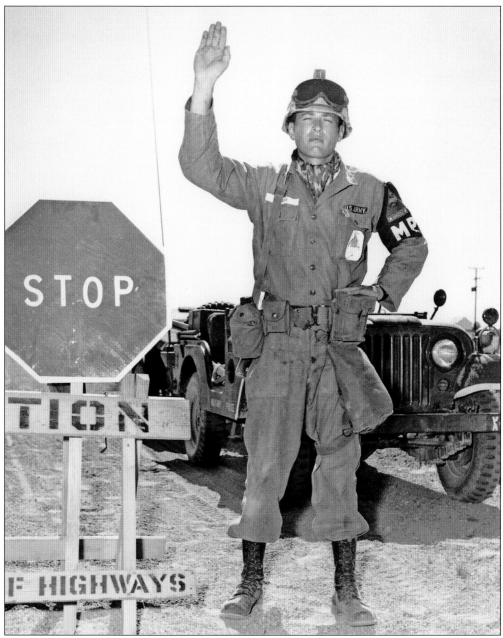
An aggressor military policeman mans a checkpoint during Desert Strike. MPs are often assigned to man checkpoints to control traffic during exercises.

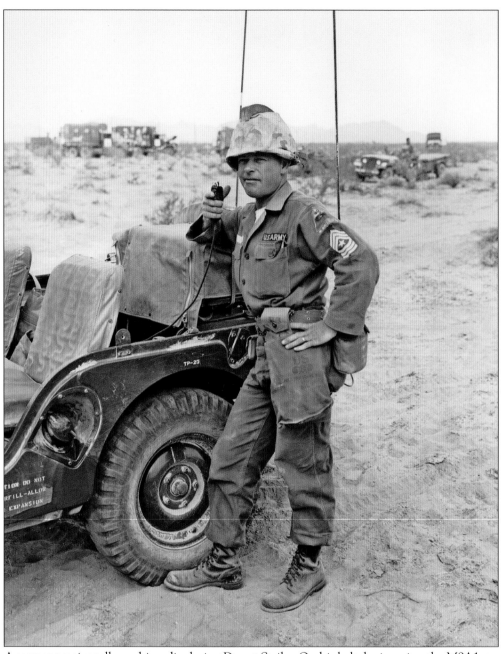
A sergeant major talks on his radio during Desert Strike. On his belt, he is caring the M9A1 gas mask. The M9 was developed in 1951 and was replaced by the M17 protective mask in the early 1960s. Some of the earlier masks were still in use until the late 1960s by units in the reserves and National Guard.

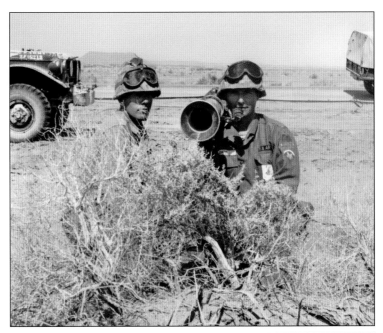

Two soldiers use bushes for concealment while manning an antitank weapon during Desert Strike. The weapon is an M20 rocket launcher, used by the US Army from its development in 1951 until it was replaced during the Vietnam War by the M72 light antitank weapon.

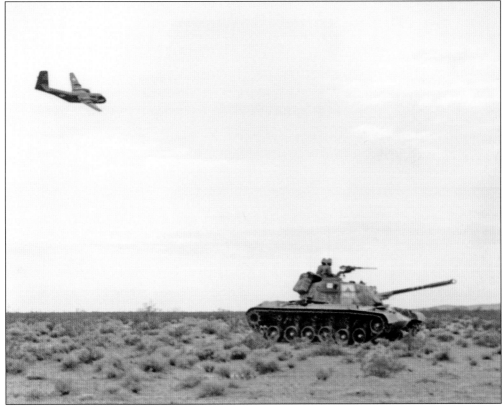

An Air Force resupply plane passes over an M48 tank during Desert Strike. Over 900 aircraft flew a variety of missions including close air support, simulated bombing runs, and resupply missions to support the over 100,000 troops in the field.

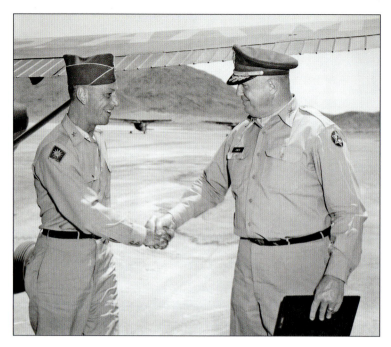

An unidentified brigadier general, possibly Brig. Gen. Robert G. Elder, is greeted by Col. Andrew R. Cheek, commander of Fort Irwin (right), at Bicycle Lake Airfield. The airfield is on a dry lake bed just north of the US Army garrison at Fort Irwin and is still in use today.

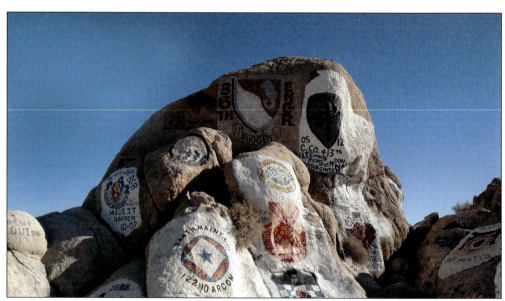

Near the entrance to Fort Irwin is Painted Rocks, where units that train at the NTC can ask for approval to paint their unit insignia on one of the rocks. The tradition began in the mid-1960s when three soldiers from the 36th Engineer Battalion painted the "Seahorse" patch of the 36th just before deploying to Vietnam. Painted Rocks is the most recognized landmark at Fort Irwin. (Author's collection.)

Three

THE GUARD TAKES OVER

In 1971, Fort Irwin was deactivated and put into surplus status. The 40th Armored Brigade assumed command of the post, with Col. Irving J. Taylor as commander. In 1974, the National Guard was reorganized and the 40th Armored Brigade and 40th Infantry Brigade became part of the reformed 40th Infantry Division. Fort Irwin became the home for summer training for the division, bringing life to the otherwise quiet post. "Most of the year there is solitude at the camp, this is relaxed living," Taylor told the *San Bernardino Sun*. "There are no urban problems, you turn on your radio and hear traffic jams outside of LA and you chuckle to yourself." Taylor, who commanded the National Guard troops during the Watts riots, stayed in command of Fort Irwin for 10 years.

The fort was used for more than just National Guard training. The active Army also used the vast expanse of Fort Irwin for large-scale exercises. Some of the exercises included Operation Devil Strike, Operation Red Thrust, Autumn Safari Exercise, and Brave Shield 17.

During the 1970s, there were several proposals on how to best make use of the facilities still remaining, but unused, on the post. Some of the ideas that were considered were a training facility for Native Americans, a JOB Corps training site, or a research facility dedicated to ecology.

In 1973, the post was considered for use as a temporary holding center for Vietnamese refugees. The local congressional representative stated in an interview that Fort Irwin was on the short list for a new secret research facility. Colonel Taylor called the announcement "political" and said the facility would go to China Lake, because of the poor condition of Fort Irwin Road.

In October 1980, the Army officially activated the National Training Center (NTC) at Fort Irwin. Taylor would remain as commander of Fort Irwin until the regular Army assumed command of the post in July 1981.

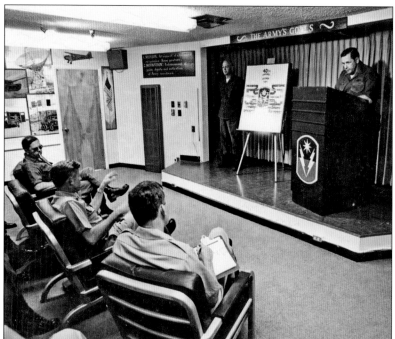

Col. Irving Taylor gives a briefing at Fort Irwin in the 1970s. (Courtesy of the 11th Armored Cavalry and Fort Irwin Museum.)

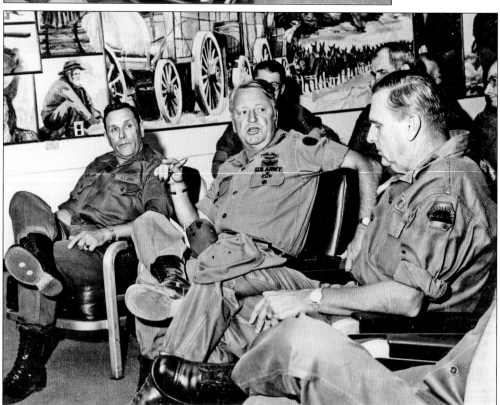

Colonel Taylor sits in during a briefing to a lieutenant general and a major general from the California National Guard. (Courtesy of the 11th Armored Cavalry and Fort Irwin Museum.)

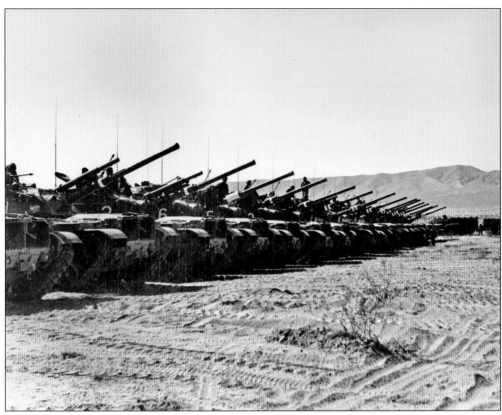

A line of M60 tanks waits for orders to move out during training at Fort Irwin. (Courtesy of the 11th Armored Cavalry and Fort Irwin Museum.)

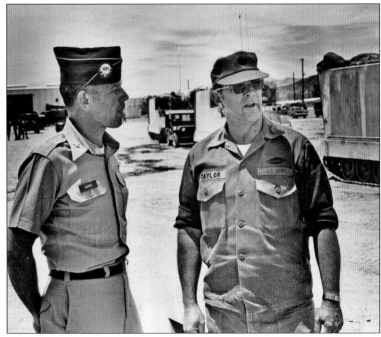

Colonel Taylor and Brig. Gen. Robert G. Gard Jr. are seen during training at Fort Irwin. Gard would reach the rank of lieutenant general. After his retirement from the Army in 1981, he became chairman of the Center for Arms Control and Non-Proliferation. (Courtesy of the 11th Armored Cavalry and Fort Irwin Museum.)

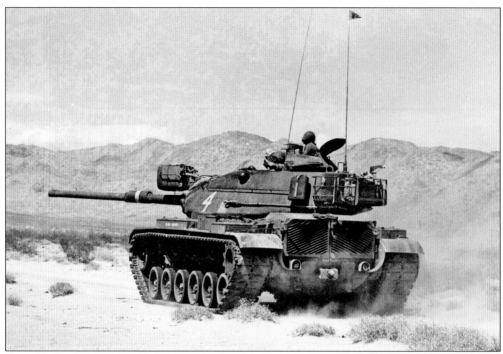

An M60 tank maneuvers during training at Fort Irwin. The M60 was introduced in 1960 and was used as the main battle tank of the United States until the M1 Abrams began deployment in 1980. (Courtesy of the 11th Armored Cavalry and Fort Irwin Museum.)

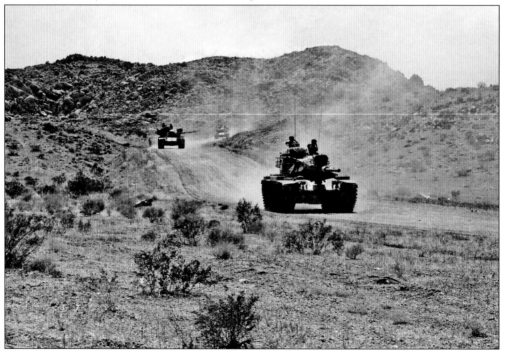

Two M60 tanks move through the training area at Fort Irwin during maneuvers in the 1970s. (Courtesy of the 11th Armored Cavalry and Fort Irwin Museum.)

Colonel Taylor consults with an observer controller (OC) during training. (Courtesy of the 11th Armored Cavalry and Fort Irwin Museum.)

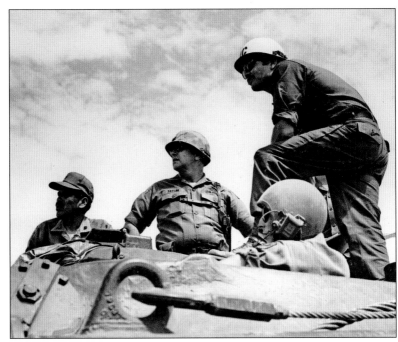

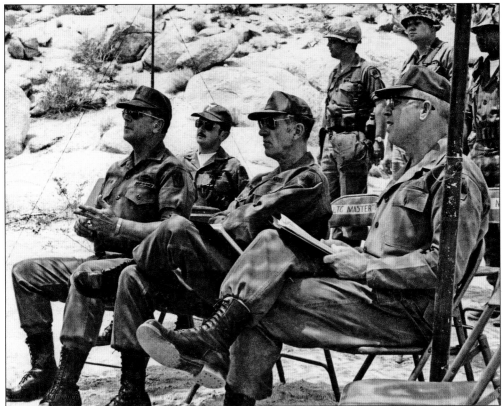

General officers from the California Army National Guard get a briefing from Colonel Taylor during a training exercise. (Courtesy of the 11th Armored Cavalry and Fort Irwin Museum.)

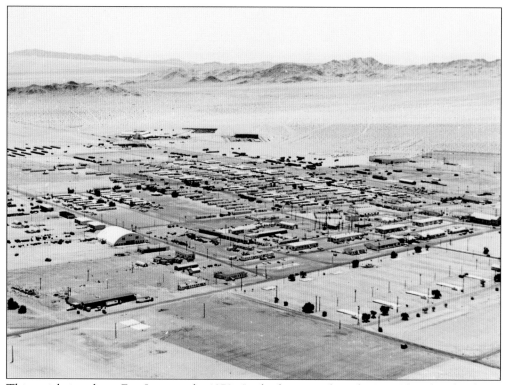

This aerial view shows Fort Irwin in the 1970s. In the foreground are the Post Chapel and Military Police Station. (Courtesy of the 11th Armored Cavalry and Fort Irwin Museum.)

Colonel Taylor supervises training from a covered observation position. (Courtesy of the 11th Armored Cavalry and Fort Irwin Museum.)

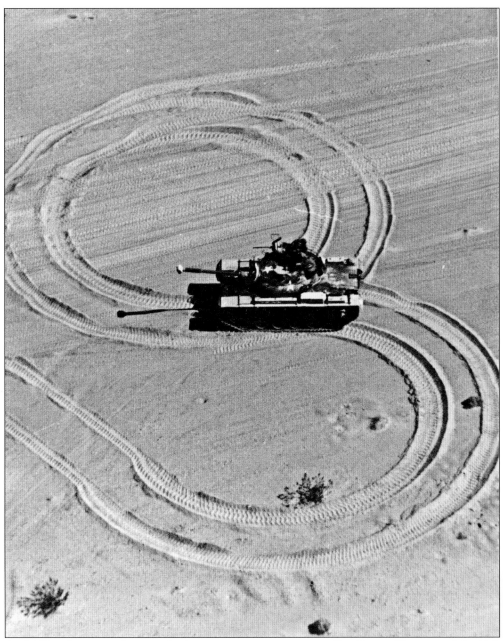

An M48 tanks turns a figure eight during training maneuvers at Fort Irwin. (Courtesy of the 11th Armored Cavalry and Fort Irwin Museum.)

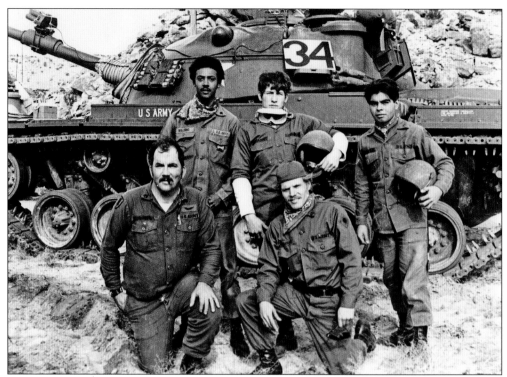
A tank crew poses by an M48 tank during training in the mid-1970s. The tank commander was nicknamed "Iron Mike." (US Army photograph by Jim Ober, 40th Infantry Division Public Affairs Office.)

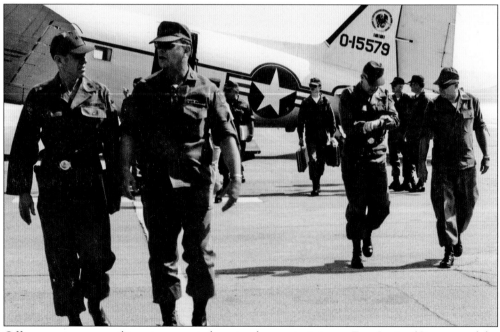
Officers arrive on a military transport plane to observe training at Fort Irwin. (Courtesy of the 11th Armored Cavalry and Fort Irwin Museum.)

Four

THE NATIONAL TRAINING CENTER

The Army had realized that it needed an installation where it could train full armored brigades—someplace with not just the land but also open airspace, free of electronic interference. It found all of that at Fort Irwin. But after 10 years of lying mostly dormant, most of the post was in disrepair. "The living was tough, but the soldiers understood what it was they were doing and what they were doing was important," said Maj. Gen. Thomas Cole, second commander of the NTC.

The process for repairing and replacing the decaying infrastructure took years, but the business of training the Army got under way. By the mid-1980s, training rotations were in full swing.

One of the many training innovations at Fort Irwin was the creation of the professional, dedicated Opposing Force (OPFOR), which became the 177th Armored Brigade. The 177th wore Soviet-style uniforms and used specially modified vehicles made to look similar to the Soviet vehicles of the time. The OPFOR proved to be an incredibly tough opponent for the training forces. "The opposing force became terribly efficient and there weren't very many wins by blue force units," said Gen. Paul Funk, fifth commander of the NTC. "But those people held us all to a higher standard than we had ever been held to before."

Also introduced into the training was the Multiple Integrated Laser Engagement System, or MILES. The system used lasers to record weapons hits on people and vehicles. Pres. George H.W. Bush acknowledged the success of the training when he visited the installation shortly before he ordered the US military into action after the Iraqi invasion of Kuwait. "Your work here at the NTC reflects the state of training throughout the Army, demanding, tough, and remember you are, all of you, preparing yourselves for combat and by doing so making a direct and lasting contribution to the preservation of peace," said Bush.

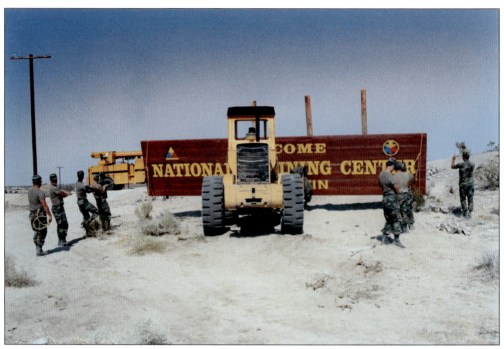

Solders use a large forklift to place the new welcome sign at the entrance of Fort Irwin. Later, armored vehicles and a helicopter would be added to the display, now known as "The Tanks."

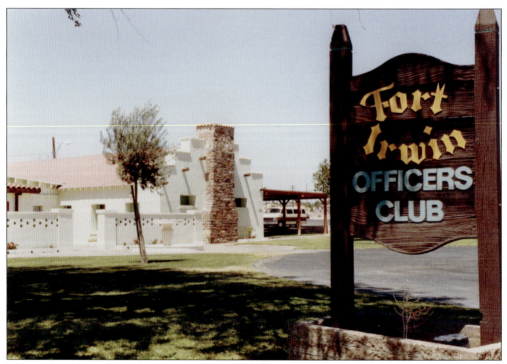

This is the sign at the old Officers' Club near Jackrabbit Park. The original Officers' Club was constructed by Italian prisoners of war during World War II.

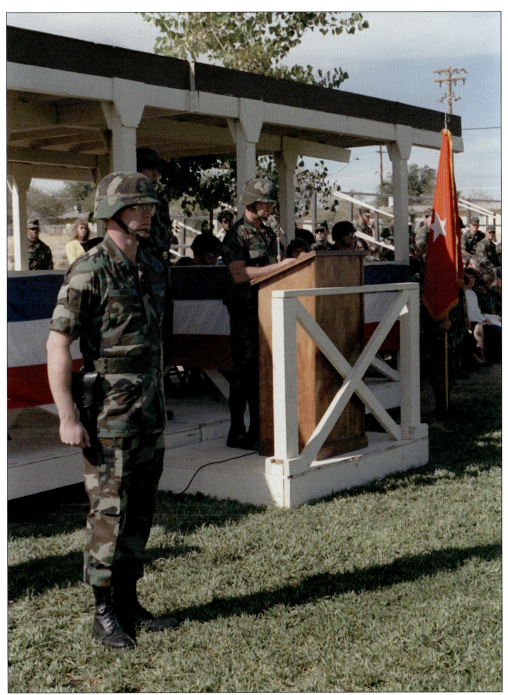

Maj. David B. Hall stands at attention as Lt. Col. Francis M. Pitaro reads from the podium at the speaker's stand during activation ceremonies for the 177th Support Battalion. Brig. Gen. Horace G. Taylor, commanding general, National Training Center and Fort Irwin, stands between the two officers. In a rare double change of command ceremony, Hall took command of the NTC Support Battalion from Pitaro before Pitaro assumed command of the newly formed 177th Support Battalion.

This is an exterior view of the Hamby Barracks. The barracks are dedicated to the memory of Col. Jerrell E. Hamby, former deputy commander for training at the NTC. Hamby was killed in a rollover accident in the training area in 1985.

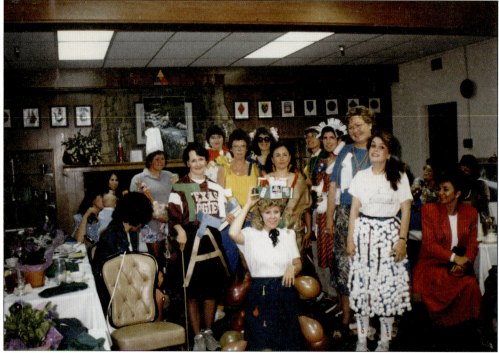

Ladies of the OWC show off their outfits at the "Mystery Lunch" on April 20, 1988. The event was held in the Officers' Club.

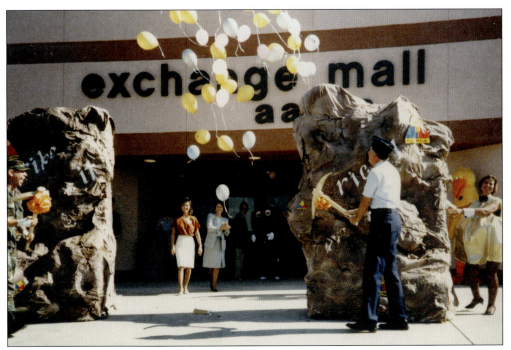

Brig. Gen. Paul Funk (left) and Brig. Gen. Jeff Kahla use golden picks to break apart a fake rock pile releasing gold and white balloons at the grand opening of the new Post Exchange on October 4, 1988. Painted on the rocks is the phrase "Strike it Rich."

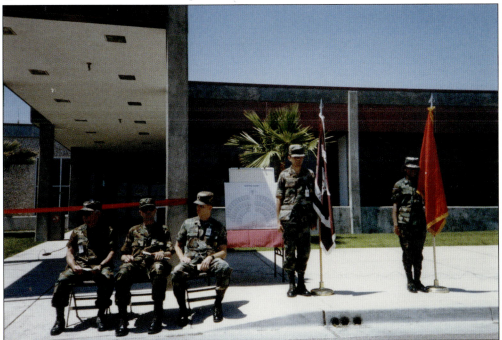

The MEDDAC commander, Col. C. Richard Knowles, and chaplain George D'Emma are pictured during the dedication of the renovated Weed Army Community Hospital in June 1989. The $1.3 million expansion added 17 examination rooms and nine physicians' offices and a new parking lot.

The OWC welcomes Gertrude Clark, the wife of the new commander, Brig. Gen. Wesley Clark, on November 3, 1989. General Clark had previously served as the commander of Operations Group during an earlier assignment to the NTC.

This is a view of the newly constructed combined Officers and Enlisted Club at Fort Irwin. The new club replaced the officers' club, built in the 1940s, and the Enlisted Club. The new facility features ballrooms, a small bar, a private dining area, a sit-down dining area, and a brewery.

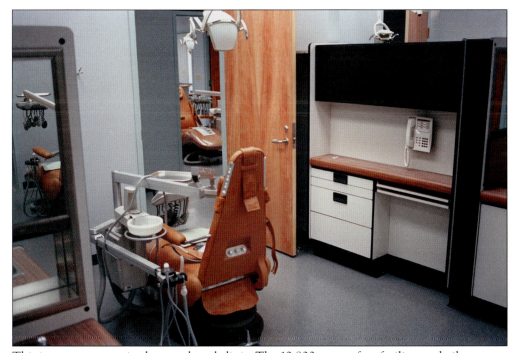

This is an exam room in the new dental clinic. The 12,800-square-foot facility was built at a cost of $2.4 million.

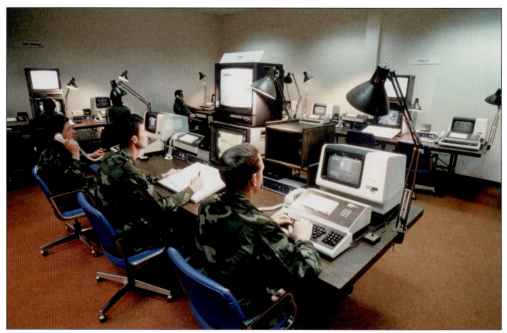

Soldiers monitor computers in one of the computer rooms in the "Star Wars" building at the NTC. The computers in the Operations Group Training Analysis and Feedback (TAF) center tracked all movements of vehicles and equipment during training rotations. The system also gave the TAF information from the MILES sensors in the training area. Naming the building after the 1979 movie was a nod to the advanced technology used at the NTC.

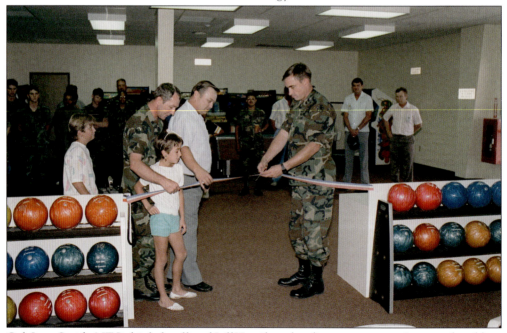

Col. Jerry Smith, NTC chief of staff, and Jeff Hamilton, bowling center supervisor, cut the ribbon reopening the remodeled bowling center on September 16, 1987. The renovation doubled the size of the center.

A member of the 177th Armored Brigade explains a Viper light antitank weapon to Lieutenant General Jenes and Maj. Gen. Mahammoud Hammad of the Egyptian armed forces at the NTC in February 1987. The brigade acts as an opposing force during exercises at the center.

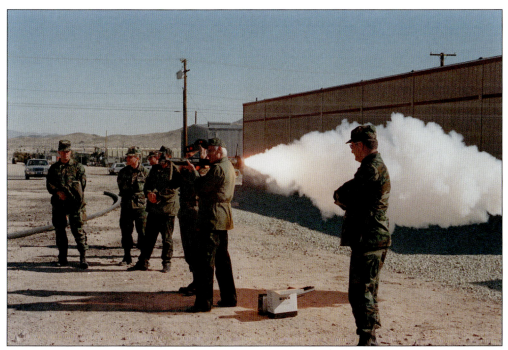

Major General Hammad of the Egyptian armed forces fires a Viper light antitank weapon during an orientation at the NTC in February 1987.

47

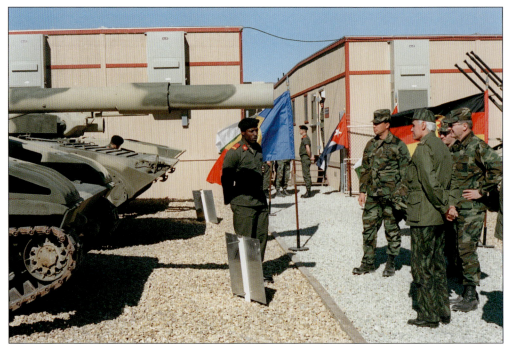

A member of the 177th Armored Brigade describes an M551 Sheridan tank modified to resemble a Soviet tank to Lieutenant General Jenes and Major General Hammad of the Egyptian armed forces at the NTC.

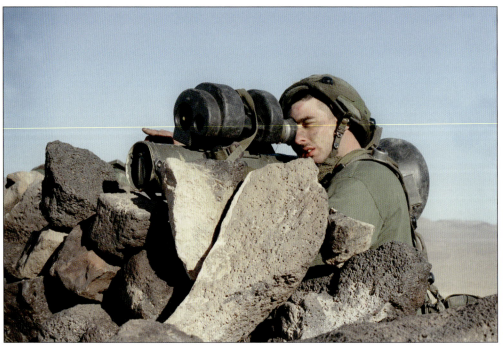

A member of 1st Battalion, 505th Infantry Regiment, 82nd Airborne Division looks through the tracker of an M47 Dragon medium antitank weapon trainer during an exercise at the NTC in November 1988.

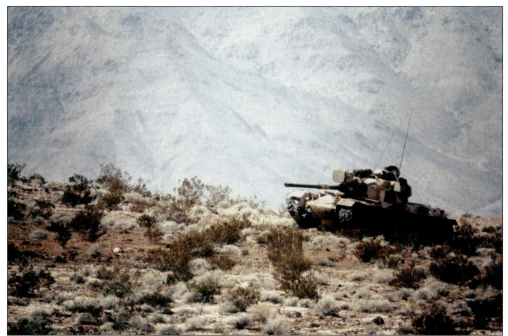

An M60A1 tank is positioned below the crest of a hill during Exercise Gallant Eagle '82. The exercise began with 3,000 soldiers from the 82nd Airborne Division from Fort Bragg, North Carolina, parachuting into the training area at the NTC. Four paratroopers died from injuries they received during the operation.

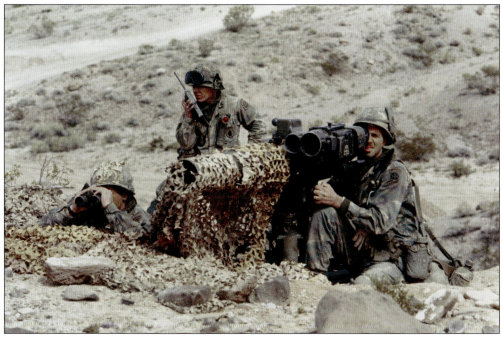

Infantrymen prepare to fire a Tube-Launched, Optically Tracked, Wire-Guided (TOW) missile system during Exercise Gallant Eagle '82 at the NTC.

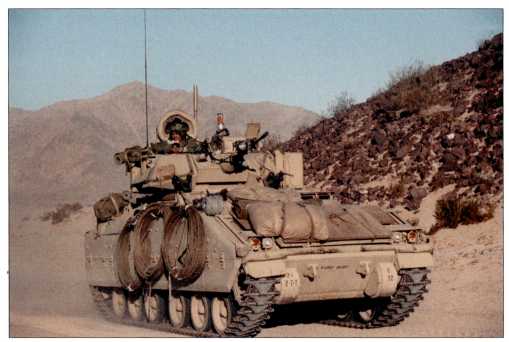

An M2 Bradley Fighting Vehicle of the 24th Infantry Division (Mechanized) moves along a road at the NTC during an exercise.

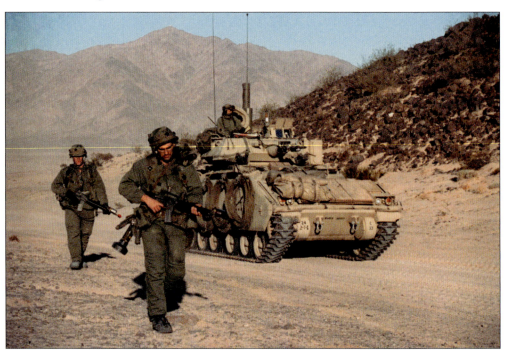

Members of a Stinger antiaircraft missile unit wearing MILES gear move along a road as an M2 Bradley Fighting Vehicle passes by. Members of the 24th Infantry Division (Mechanized) and 1st Battalion, 505th Infantry Regiment, 82nd Airborne Division were conducting an exercise at the NTC.

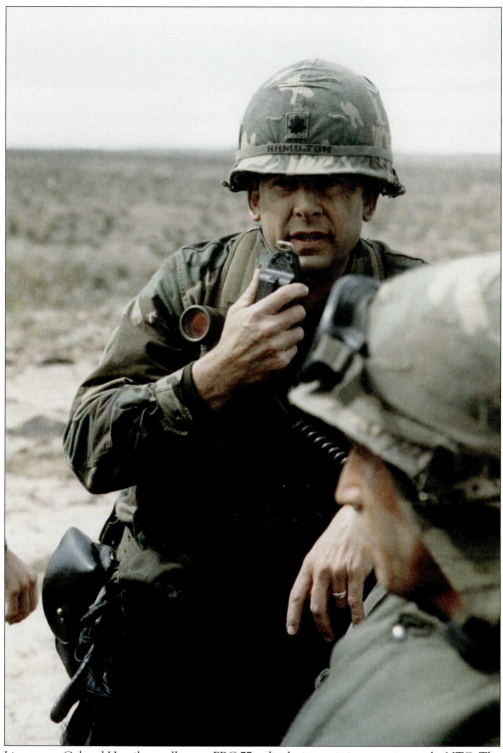

Lieutenant Colonel Hamilton talks on a PRC-77 radio during training exercises at the NTC. The PRC-77 was affectionately know to the troops as a "Prick 77."

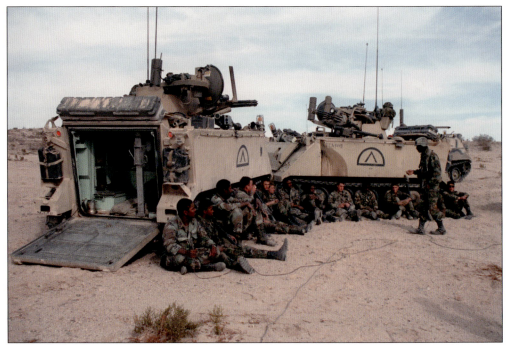

Soldiers with the 24th Infantry Division (Mechanized) lean against a pair of M163 Vulcan self-propelled antiaircraft guns as they receive an after-action briefing during an exercise at the NTC. The M163 is a weapon system consisting of an M168 Vulcan 20-millimeter cannon with radar fire control mounted on an M113 armored personnel carrier.

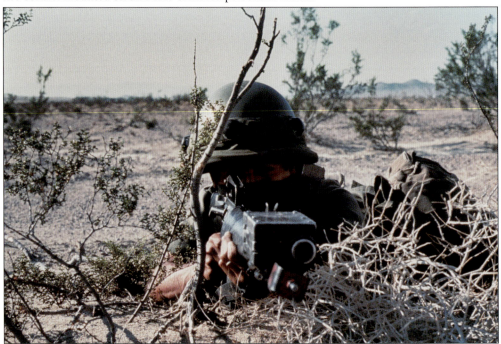

A soldier aims his M16A1 rifle while lying in the prone position during a training exercise at the NTC. The soldier's rifle is equipped with a MILES transmitter.

Carla Smythe, Lynn Moon, Sarah Palmer, and Laura Tollben pose at a newcomers' tea at Quarters 1 hosted by Sharon Wallace on August 23, 1995. (Courtesy of the 11th Armored Cavalry and Fort Irwin Museum.)

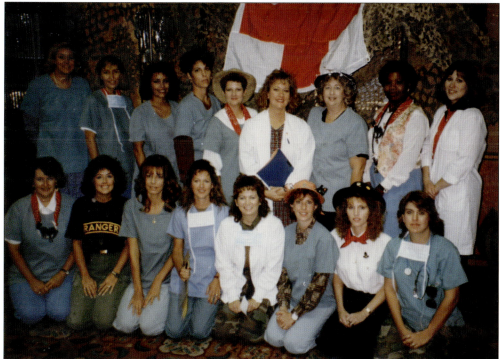

A MASH party was held at the Officers' Club in October 1995. MASH is the acronym for Mobile Army Surgical Hospital. MASH parties were popular celebrations of the TV show *MASH*, which ran from 1972 to 1983. (Courtesy of the 11th Armored Cavalry and Fort Irwin Museum.)

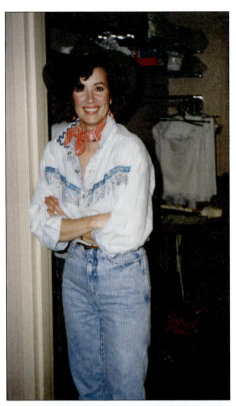

Vickey Schomaker poses during Wild West Night at the Officers' Club in March 1990. (Courtesy of the 11th Armored Cavalry and Fort Irwin Museum.)

An old miner waits with drink in hand as part of the decorations for Wild West Night at the Officers' Club in March 1990. (Courtesy of the 11th Armored Cavalry and Fort Irwin Museum.)

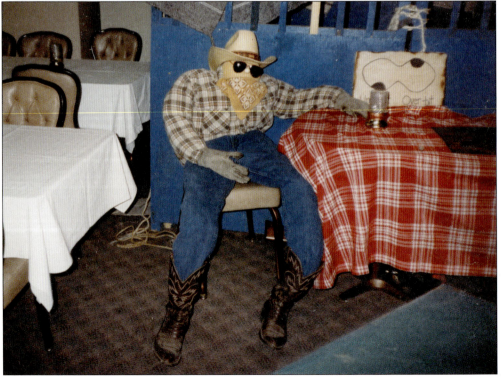

The unveiling of *Kyle the Coyote* at the visitors' center is pictured in 1988. The sculpture was donated by Fort Irwin contractor Dyncorp and designed by Howard Pierce. Unveiling the sculpture are Chuck Herring, Dyncorp general manager; Daphne Schmidt, OWC president; and Adele Dunn, Enlisted Wives Club president. According to legend, failure to give Kyle a kiss when transferring from Fort Irwin guarantees a future assignment back at the remote installation.

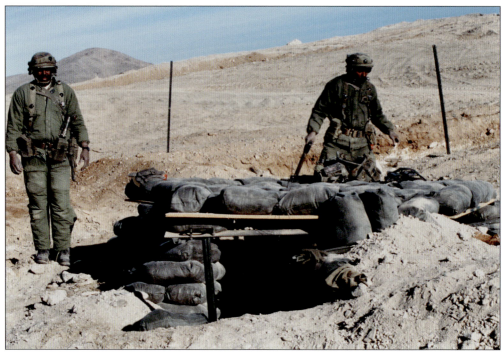
Soldiers work on an improved fighting position in the training area of the NTC.

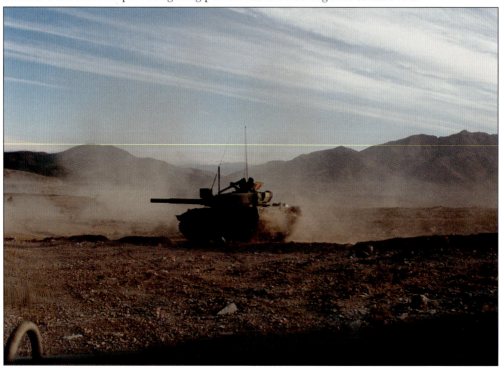
An OPFOR M-551 Sheridan light tank belonging to the 11th Armored Cavalry Regiment, visually modified to resemble a Soviet T-72 main battle tank, moves forward to attack the Rotational Training Unit during a training exercise at the NTC.

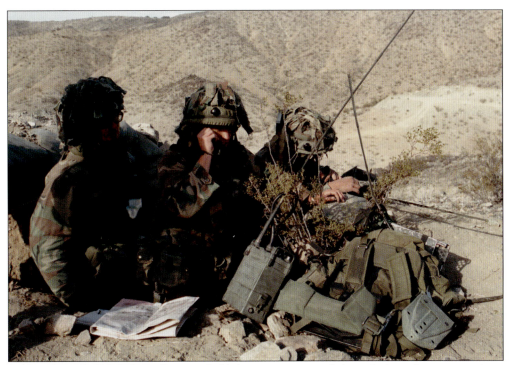

Soldiers from the 7th Infantry Division hold their positions in a fighting hole as they communicate with headquarters during an exercise.

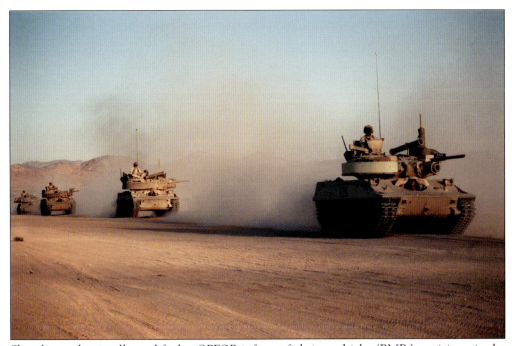

Sheridan tanks visually modified as OPFOR infantry fighting vehicles (BMPs) participate in the 177th Armored Brigade battle exercise at the NTC.

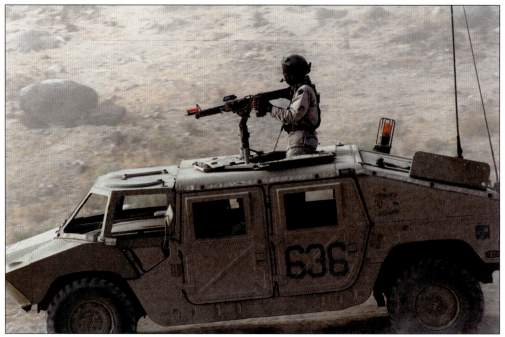

Sgt. David Price runs the machine gun in a high-mobility multipurpose wheeled vehicle (HMMWV), visually modified as an amphibious scout car (BRDM), OPFOR, in a battle exercise of the 177th Armored Brigade at the NTC.

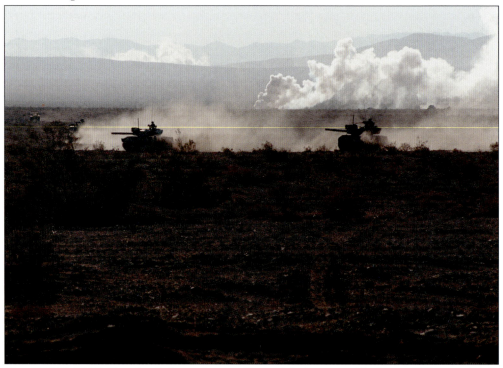

Two OPFOR M551 Sheridan light tanks visually modified to resemble Soviet T-72 main battle tanks advance through the desert to join the attack on the Blue Forces during an exercise.

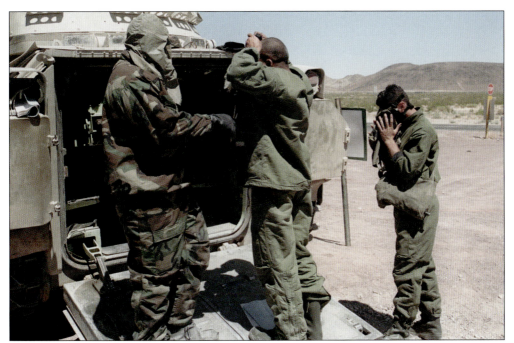

Soldiers of the 177th Armored Brigade suit up for battle testing of chemical warfare protective gear at the NTC.

First Lieutenant Eziezynski from the 177th Armored Brigade waits in a HMMWV, visually modified to represent an amphibious scout car (BRDM), at the NTC during a battle exercise.

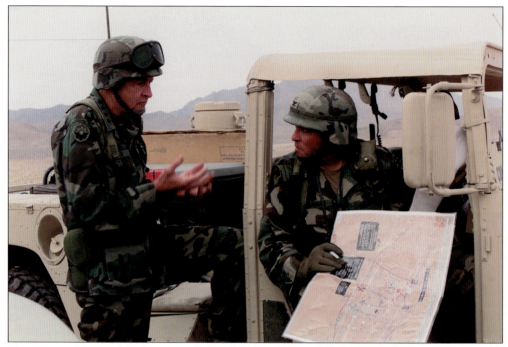

Gen. Dennis Reimer, US Army chief of staff (left), chats with Col. James Thurman, commander Operations Group, Fort Irwin, during his visit to the NTC to observe training activities. Thurman later became the commander of the NTC.

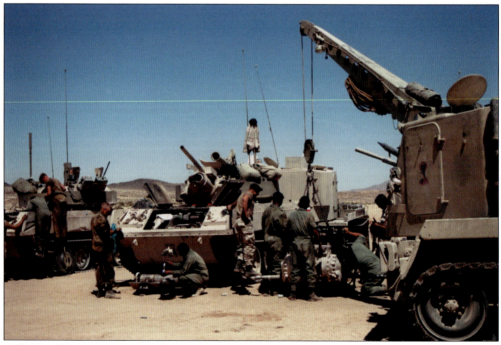

OPFOR soldiers, members of the 177th Armored Brigade, are preparing armored vehicles for a battle exercise during field activities at the NTC.

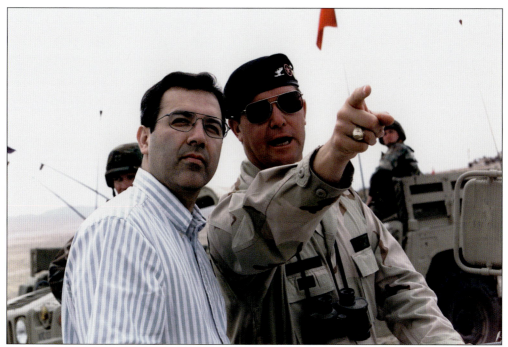

Secretary of the Army Louis Caldera visits the NTC at Fort Irwin. Secretary Caldera (left) listens as 11th Armored Cavalry Regiment commander Col. John Rosenberger explains battle tactics.

M.Sgt. Lonnie Eaker, an enlisted terminal attack controller (ETAC) assigned to Detachment 6, 57th Wing, Nellis Air Force Base in Nevada, USAF Air Warrior Team, coordinates close air support for participating US Army ground forces during a deployment exercise.

M.Sgt. Lonny Eaker keeps an eye on the battlefield and stays near his HMMWV and field radio in the event he needs to call for close air support.

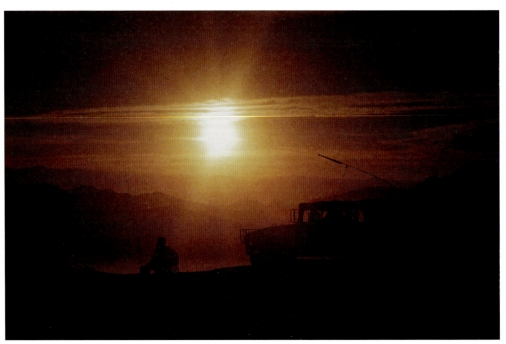

As the sun sets in the Mojave Desert, a lone enlisted terminal attack controller watches for an OPFOR attack. The mission of the ETAC is to call for close air support for US forces during combat operations.

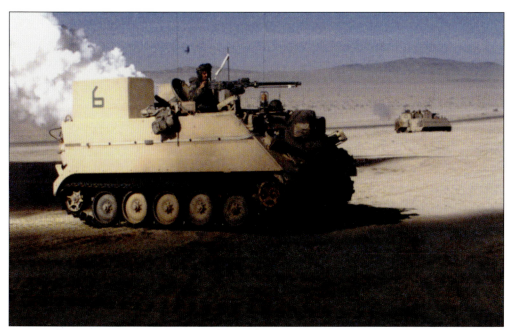

On March 19, 1997, a US Army 31st Chemical Company M1059 "smoke generator" (M113A2 Armored Personnel Carrier [APC] with two M54 smoke generators) clogs up the battlefield with smoke during the Advanced Warfighting Experiment (AWE) at Fort Irwin. More than 6,000 soldiers took part in the six-week exercise that capped nearly two years of training. The AWE tested 72 initiatives ranging from new computer equipment like the Applique to reorganization of unit structure.

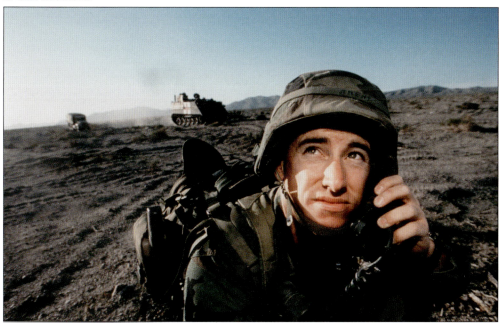

An armored medical personnel carrier approaches SrA. Anthony Brent, an ETAC assigned to Detachment 6, 57th Wing, USAF Air Warrior Team, as he coordinates close air support for participating US Army forces during the deployment exercise.

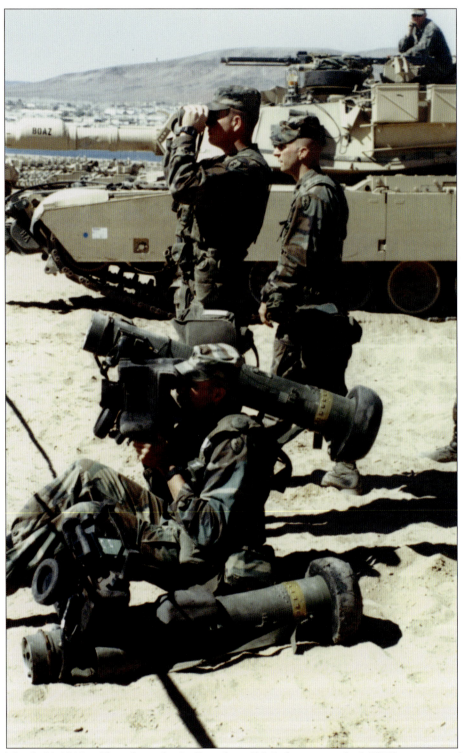

On March 24, 1997, soldiers from the 1st Battalion, 5th Infantry test the MILES system on their Javelin advanced antitank weapons system–medium in preparation for the AWE at the NTC.

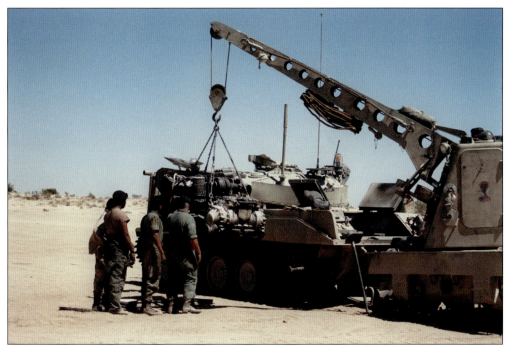

OPFOR soldiers, members of the 177th Armored Brigade, prepare armored vehicles for a battle exercise during field activities at the NTC.

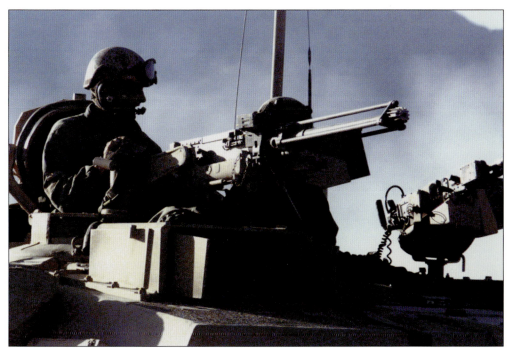

On March 19, 1997, the commander of an M1 Abrams main-battle tank stands in the open hatch beside a MILES-equipped 0.50-caliber M2 heavy barrel machine gun.

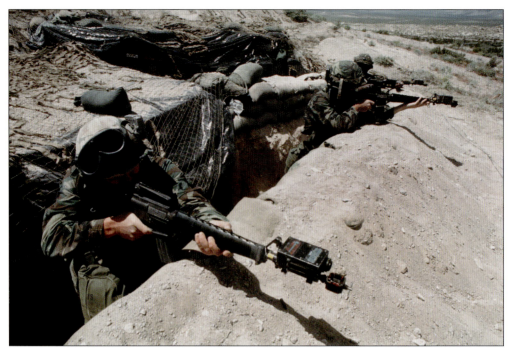
Airmen aim M16A1 rifles equipped with MILES during Exercise Crown Defender at Fort Irwin in 1983. Training rotations at the NTC often include military members of the different services and other allied nations.

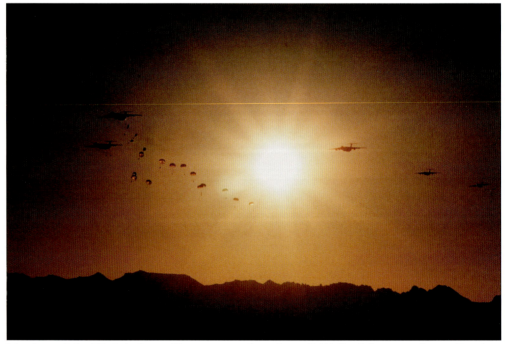
Members of the 82nd Airborne Division parachute from C-141 Starlifter aircraft over Landing Zone Nelson during Exercise Gallant Eagle in 1982.

Five

9/11 AND BEYOND

After the attacks on the United States on September 11, 2001, and the invasion of Afghanistan, training at the NTC began to change from the tank-on-tank clashes of the past to a more hybrid threat such as the Army experienced in the Middle East. Villages were hastily built, first out of storage sheds and later using stacked shipping containers, with holes cut into them for doors and windows.

The opposing force, now the famed 11th Armored Cavalry Regiment, filled many roles during the simulations. The regiment still formed the opposing military force, but now also represented insurgent populations, criminal organizations, local and regional governments, and local civilian populations.

In 2004, the NTC began to hire contract employees who had grown up in the Middle East to play many of the key civilian roles. These new players were able to bring a new level of cultural understanding to the exercise and gave training units a much better idea of the possible pitfalls of religious and cultural differences when operating in a foreign land.

To add additional realism, Fort Irwin turned to nearby Hollywood to make the containers look more realistic and add special effects to the training simulations.

Fort Irwin continued to change and adapt training to reflect the evolving situations in both Afghanistan and Iraq. At the peak of the wars, new enemy tactics could be inserted into training about three days after being observed overseas. "People who have been to this fight understand what needs to happen at the NTC to be relevant and to lead change," said Gen. Robert Cone, 15th commander of the NTC.

Training at the NTC continues to evolve, as the Army is always looking to future threats and getting forces ready to win the first fight. "We will continue to see this blend in this decisive action training where we have to be able to operate at a level against a peer threat, but we still have to keep in mind the population and the counter insurgency and all those variables that are associated with that," said Jeff Broadwater, 21st commander of the NTC. "We can't fight the last war, but we need to learn from it."

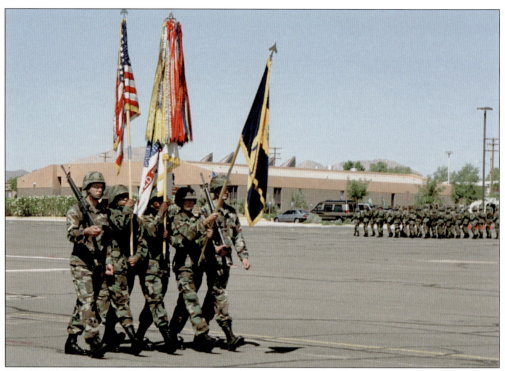
The NTC Honor Guard presents the colors during a change of command ceremony. Brig. Gen. William G. Webster Jr. relinquished command to Brig. Gen. James D. Thurman.

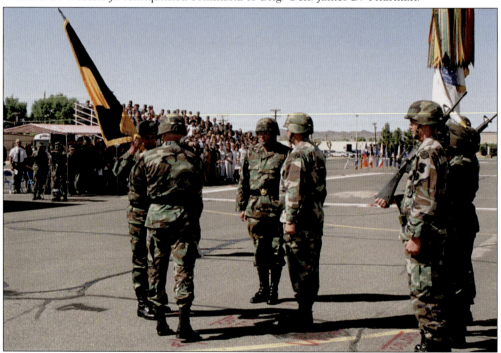
Brig. Gen. William W. Webster Jr., commander of the NTC, passes the organizational flag to FORSCOM (US Army Forces Command) commander Gen. John W. Hendrix.

A World War II M4 Sheridan "Betsy" medium tank is pictured during the 100th anniversary celebration of the Black Horse Regiment at the NTC. S.Sgt. Mary Jones (top) and Sgt. Katherine Brown were honorary participants in the activities.

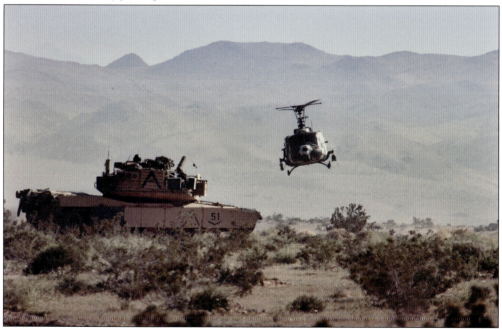

A UH-1 60 Sokol helicopter flies over an M1 Abrams tank during exercises at the NTC. Sokol helicopters were used to simulate OPFOR aviation assets during training.

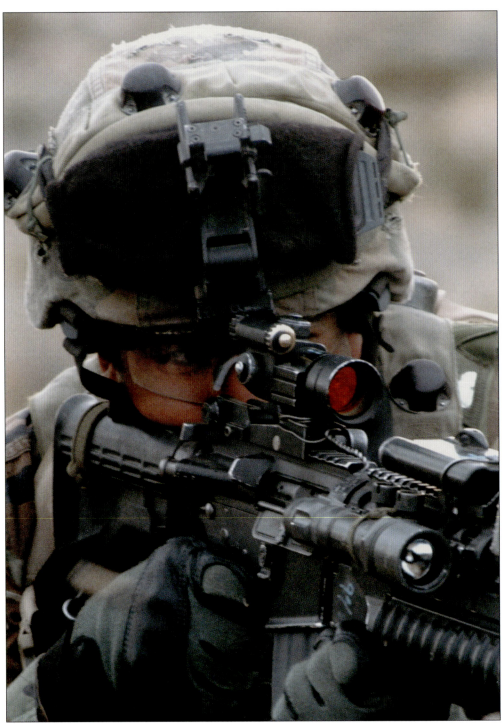

A 2nd Brigade Combat Team (BCT), 10th Mountain Division soldier aims his 5.56-millimeter M4 rifle from his fighting position at other American soldiers role-playing Iraqi insurgents during the simulated battle in Gahr Albai and Millawa Valley on one of the ranges at the NTC during Rotation 06-05, a training program to enhance a unit's desert war fighting skills for future deployments.

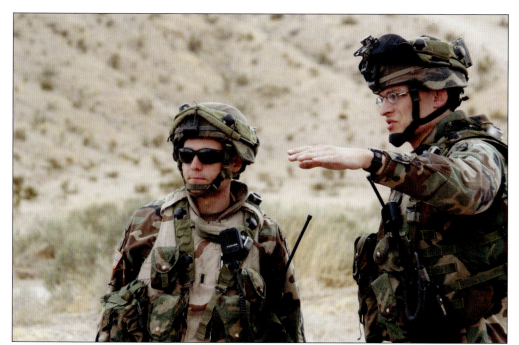

Two 10th Mountain Division soldiers discuss how they are going to establish their checkpoint on one of the ranges at the NTC during Rotation 06-05.

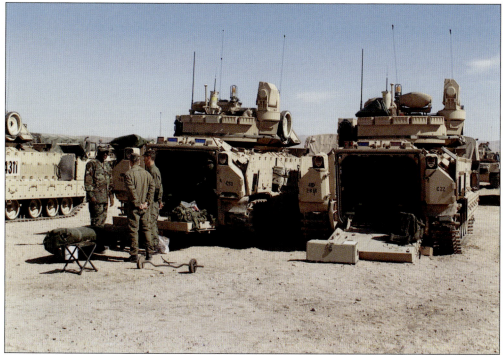

Soldiers assigned to the 4th Infantry Division stand next to their M2A3 Bradley Infantry Fighting Vehicles, inside the "Dust Bowl" staging area at the NTC.

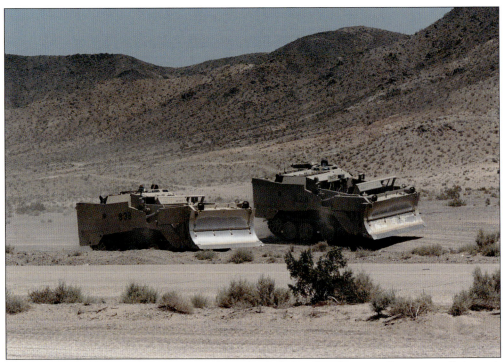
Two M9 Armored Combat Earthmovers from the 58th Combat Engineer Company roll through an open desert area, with their dozer blades in the sprung mode.

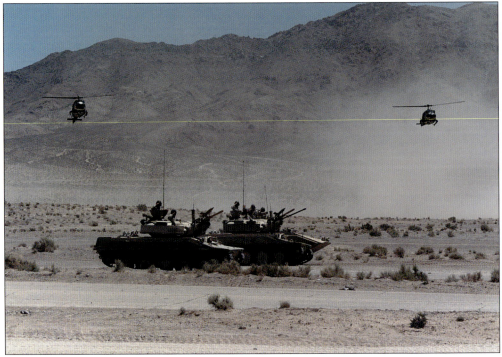
Two M551A1 Armored Reconnaissance Airborne Assault Vehicles are flanked by two low-flying UH-1 "Huey" helicopters.

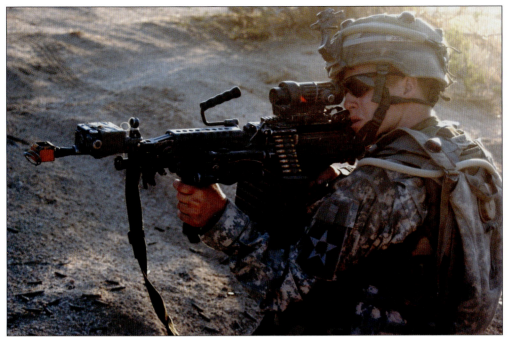

A soldier from 1st Battalion, 9th Infantry Regiment, 2nd Brigade, 2nd Infantry Division sights in on insurgents from the scope of an M249 automatic weapon during an early morning mock battle at the NTC. The 2nd Infantry Division was participating in desert training to sharpen its warfighter skills prior to deployment to Iraq.

Soldiers from the 2nd Infantry Division take defensive positions in the training town of Medina Wasl during a training rotation in July 2006. (US Army photograph by Ken Drylie.)

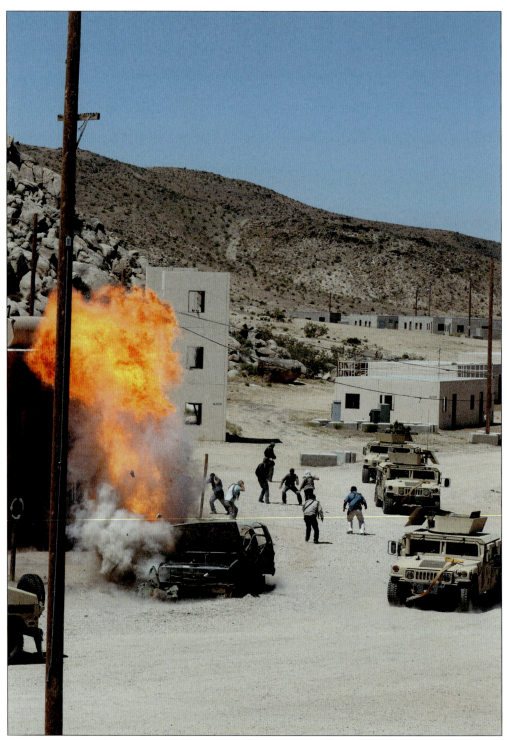

Army contract employees, playing the citizens of the training village of Razish, react to a simulated improvised explosive device detonated as a combat patrol passed. The NTC uses actors and Hollywood special effects to add realism to training. (US Army photograph by Ken Drylie.)

Six

Political Figures and Hollywood Visitors

The National Training Center at Fort Irwin is one of the most visited installations in the US Army. The importance of the training conducted at the NTC attracts military and civilian leaders from the United States and allied countries. The proximity to the entertainment industry makes Fort Irwin a natural choice to support production of movies and television shows about the Army.

One of the earliest movies to use Fort Irwin was the 1979 film *Hair*. Although most of the movie is set in New York, the final scenes are supposed to be at a US Army base in Nevada. The production team was allowed to use barracks at Fort Irwin and the airfield at Daggett for the departure of one of the main characters as he deploys to Vietnam. The production unit also employed over 1,000 soldiers for the scene.

Fort Irwin's Bicycle Lake is the testing ground in the opening scene of the movie *GI Joe*. In the scenes, an experimental "nanoprobe" weapon is fired at a moving tank. The tank "dissolves" when attacked by the nanoprobes.

Personnel from Fort Irwin have also helped train actors for their upcoming roles to add realism and accuracy to movies. Brad Pitt and Shia LaBeouf came to the post to meet real Army tankers and get up close with military equipment prior to filming the movie *Fury*. For the movie *Transformers*, Josh Duhamel, Tyrese Gibson, and Zack Ward all received several days of military training by soldiers of the 11th Armored Cavalry to make their battle scenes more believable. The US Army 759th Explosive Ordnance Disposal Unit was able to put Jeremy Renner and other actors in *The Hurt Locker* through some of the training it takes to become an EOD technician.

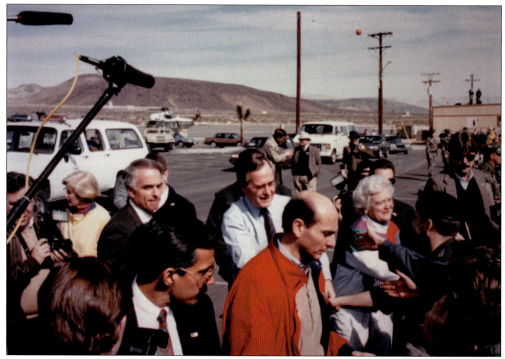

Pres. George H.W. Bush and First Lady Barbara Bush are welcomed to the NTC during their visit in 1990. Bush was there to observe training prior to the start of Operation Desert Shield.

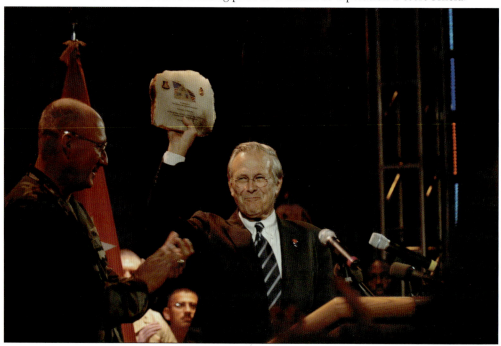

Secretary of Defense Donald Rumsfeld holds a quartz rock with the unit insignias of the units stationed at Fort Irwin during his visit to the installation in August 2006. (US Army photograph by Ken Drylie.)

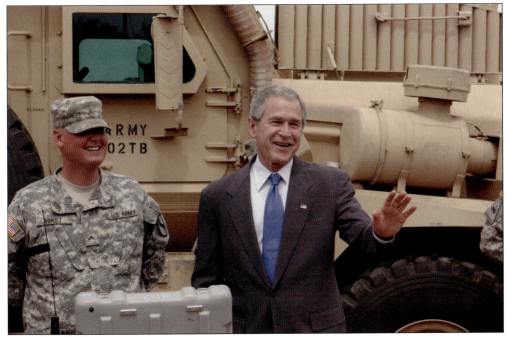

Pres. George W. Bush jokes with the press pool during a visit to the NTC at Fort Irwin. Bush had just been shown a demonstration of an Explosive Ordnance Disposal robot, which the president had the chance to operate. (US Army photograph by Ken Drylie.)

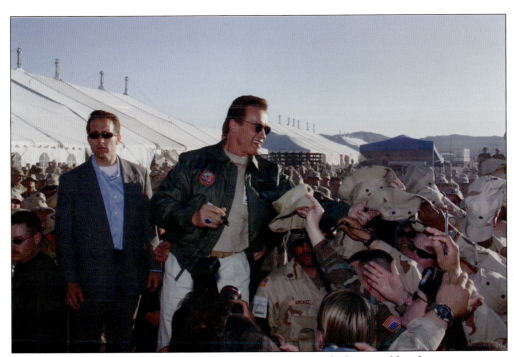

California governor Arnold Schwarzenegger returns a hat to a deploying soldier during a ceremony for the 1-185th Armor of the 40th Infantry Division. (US Army photograph by Ken Drylie.)

In 1978, director Milos Foreman brought the production crew for the movie *Hair* to Fort Irwin. The post was used to represent the installation where George Berger (Treat Williams) fills in for Claude Bukowski (John Savage). Bukowski's unit suddenly deploys before Bukowski can return, so Berger takes his place in the war in Vietnam. These are the last of the barracks buildings that were used in the film. (US Army photograph by Ken Drylie.)

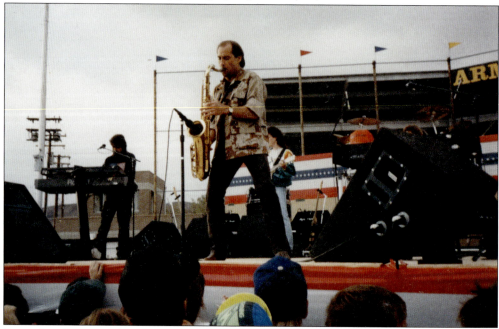

Singer Lee Greenwood performs at Army Field in a concert at Fort Irwin. Greenwood's anthem is "God Bless the USA." Although he wrote the song in response to the downing of Korean Air Lines Flight 007, it came to be associated with the attacks of September 11, 2001.

R. Lee Ermey, host of *Mail Call*, poses on top of a Bradley Fighting Vehicle during filming at Fort Irwin. Ermey first gained prominence as Gunnery Sergeant Hartman in *Full Metal Jacket*. (US Army photograph by Ken Drylie.)

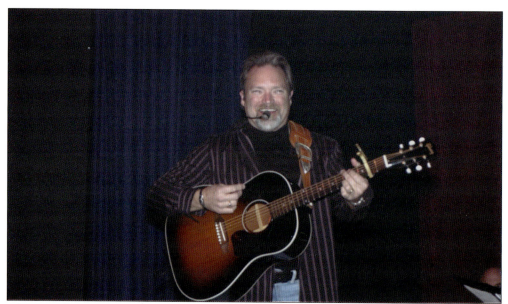

John Berry performs at Ingalls Recreation Center at the NTC. Berry is the brother-in-law of 11th Armored Cavalry commander Col. Mark Calvert. (US Army photograph by Ken Drylie.)

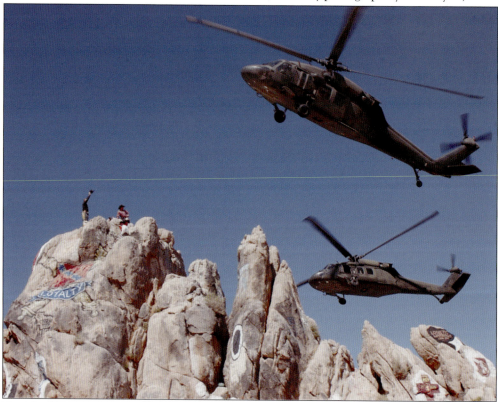

Two Blackhawk helicopters fly over Painted Rocks during filming of the television special *Beyond the Bull*, a 10-part miniseries following the lives of three professional bull riders. (US Army photograph by Ken Drylie.)

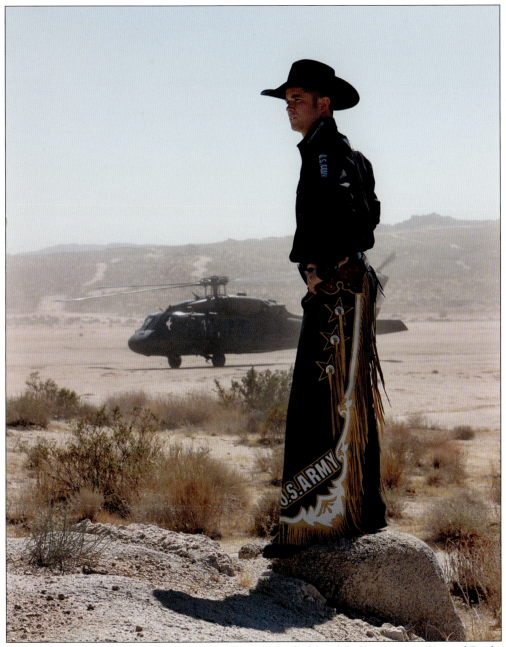

An Army-sponsored bull rider poses near a departing Blackhawk helicopter near Painted Rocks at the NTC. (US Army photograph by Ken Drylie.)

Jeremy Renner suits up in an explosive ordnance disposal suit while preparing for his role in *The Hurt Locker*. Renner spent time training with Fort Irwin's 759th EOD to get ready for the film. (US Army photograph by Ken Drylie.)

Michael Guillen, host of *Where Did It Come From?*, poses with members of the 11th Armored Cavalry and Fort Irwin Public Affairs Office during filming of the show at the 11th ACR Horse Detachment Stables. (US Army photograph.)

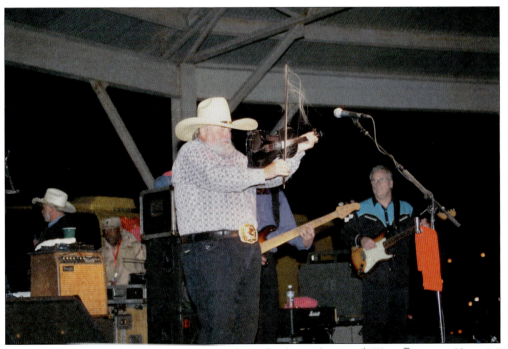

Country music legend Charlie Daniels performs his hit "The Devil Went Down to Georgia" during a concert at Army Field at the NTC on October 22, 2004. (US Army photograph by Ken Drylie.)

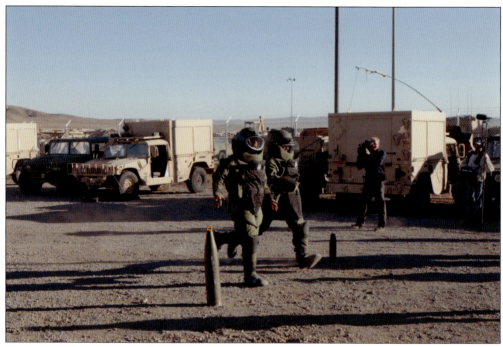

Comedians Steve Byrne and Bryan Callen attempt to run a footrace while shooting a segment for Comedy Central. The comedians got a taste of EOD training from the soldiers of the 759th EOD at Fort Irwin. (US Army photograph by Ken Drylie.)

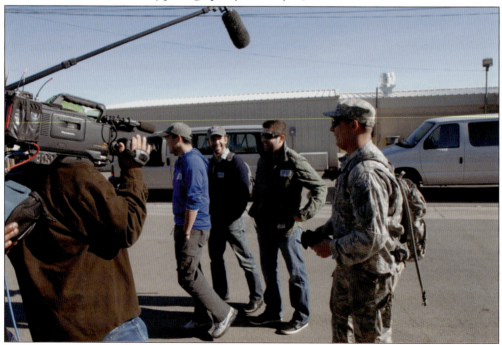

Steve Byrne, Bryan Callen, and Sam Tripoli film segments for Comedy Central. The segments played in between sets on a *Comedy Central Stand-Up* episode. (US Army photograph by Ken Drylie.)

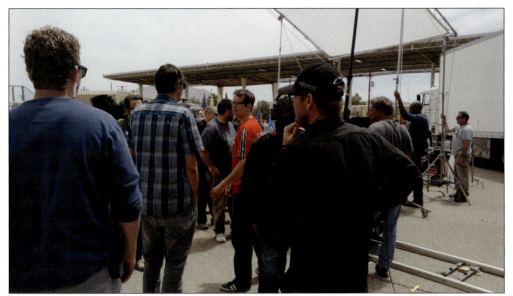

Rickey Schroder directs actors during filming of a television commercial for the US Army Chaplain Corps. (US Army photograph by Ken Drylie.)

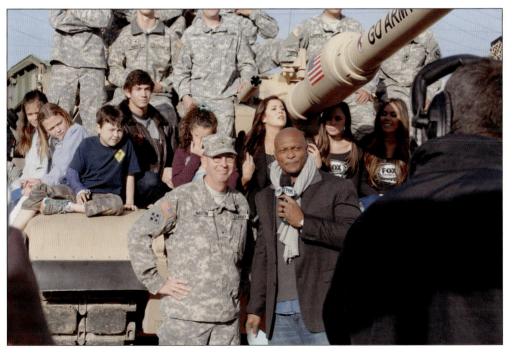

During an interview for Fox Sports Thanksgiving Day pregame show, NTC commander Brig. Gen. Ted Martin told Fox Sports commentator Eddie George, "I have the best job in the Army, commanding the National Training Center." The show was broadcast live from the 430,000-acre NTC training area known as "the Box." (US Army photograph by Ken Drylie.)

Henry Rollins speaks to the camera during filming of *10 Things You Don't Know About* at the NTC and Fort Irwin. The show informed audiences of 10 little-known facts about various subjects. The show ran from 2012 to 2014. (US Army photograph by Ken Drylie.)

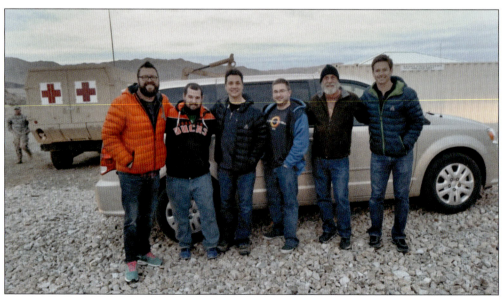

The hosts of *Top Gear America* pose with fans during a break while filming an episode of the episode "Military Might." The show features civilian vehicles the hosts believe could be used by the US Army. Pictured from left to right are host Rutlege Wood, Randal Anderson, host Adam Ferrara, Kenny Drylie Jr., Kenneth Drylie Sr., and host Tanner Foust. (US Army photograph by Ken Drylie.)

The emergency entrance to Weed Army Community Hospital is pictured in 1980. Originally built in the 1960s, the hospital received a major upgrade in the late 1980s.

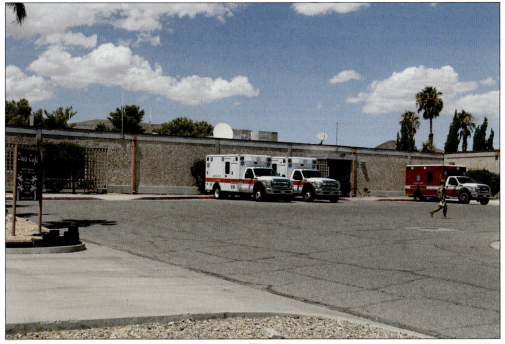

This image shows the emergency entrance to Weed Army Community Hospital in 2017. The hospital was replaced by a new facility in September 2017, and the structure was scheduled for demolition. (US Army photograph by Ken Drylie.)

The post movie theater was the Charles C. Tucker Auditorium. The original theater featured a single screen and showed first-run movies to entertain the soldiers stationed at the remote post. When remodeled, the theater was divided in half, allowing two different movies to be shown at the same time.

The post movie theater is seen in 2017. The area in front of the theater is now Constitution Park. (US Army photograph by Ken Drylie.)

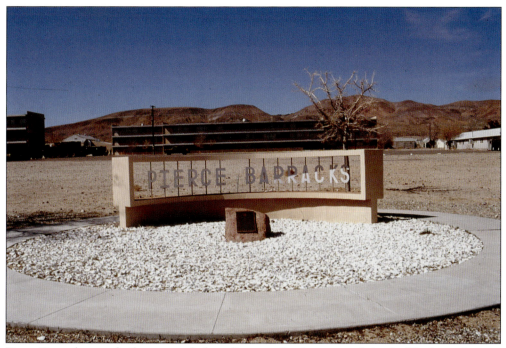

Pierce Barracks were built as part of a battalion area for the support brigade. The barracks were built near the offices occupied by the brigade headquarters and within easy walking distance of the unit dining facility. The dining facility was converted in the late 1980s into the 11th Armored Cavalry and Fort Irwin Museum.

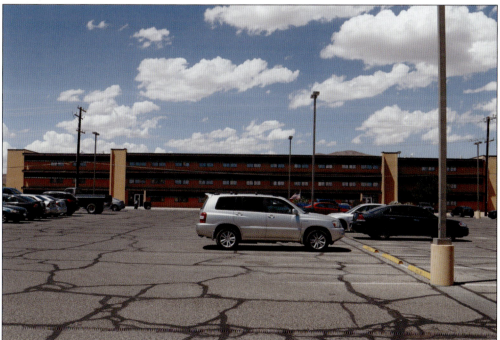

Pierce Barracks was remodeled in 2016. The location of the original sign for the barracks is now in the middle of a temporary classroom. (US Army photograph by Ken Drylie.)

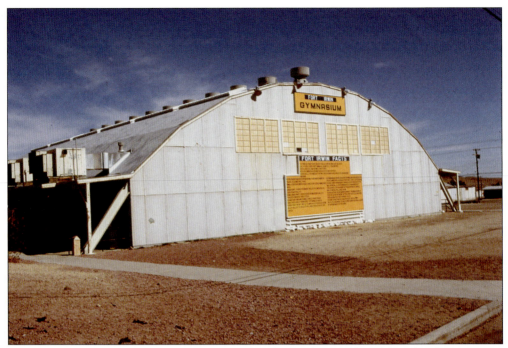

Chuckwalla Gym was named for the desert chuckwalla lizard, a large lizard found in the Fort Irwin area. The sign on the building, "Fort Irwin Facts," was moved from a position approximately 36 miles from the post to a site near Painted Rocks, and was then attached to the gym.

Renamed Memorial Gym in 2008, the gym has been renovated several times. (US Army photograph by Ken Drylie.)

Pictured are the Commissary and Post Exchange in the 1980s. The power was once so unreliable that the commissary would not stock milk because the refrigeration units would consistently malfunction. The nearest store to purchase milk was in Barstow, 36 miles away.

The buildings that housed the commissary and exchange are now a strip mall, hosting the post office, the Exchange Furniture Store, a car rental desk, an alterations shop, and a printing shop. (US Army photograph by Ken Drylie.)

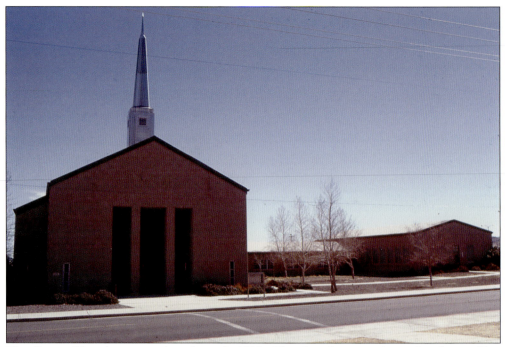

The Center Chapel is pictured in the early 1980s. The chapel is one of two churches on Fort Irwin and is the centerpiece for religious services on the post. The chapel underwent extensive repairs after being damaged by floods in 2013.

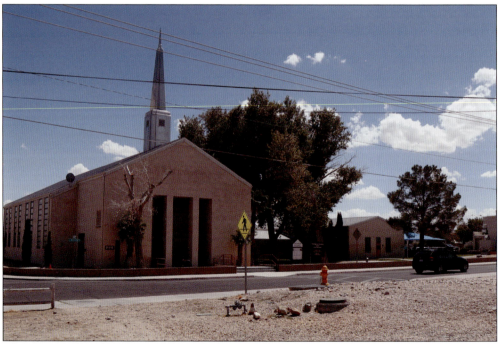

The Center Chapel is shown in 2017. The wall in front was added after the floods of 2013 and 2015 caused extensive damage to the facility. (US Army photograph by Ken Drylie.)

The Fort Irwin Military Police Station is pictured above in the early 1980s and below in 2017. The station was remodeled and expanded several times, but the original structure still remains underneath the more modern facade. (Below, US Army photograph by Ken Drylie.)

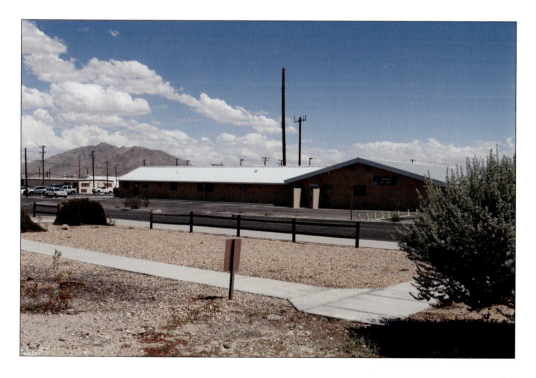

One of the new facilities constructed during the 1980s was the post Burger King. Built in the vicinity of the Post Exchange and Commissary, Burger King would relocate several years after the new commissary opened.

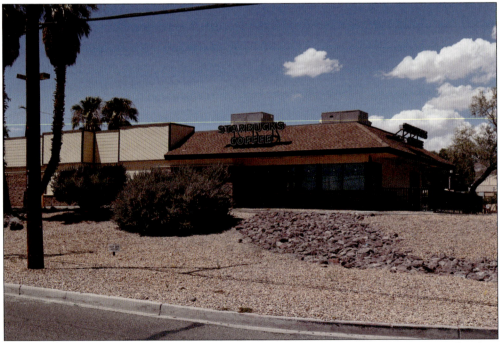

After Burger King moved, the building was repurposed to house the first Starbucks coffee shop on the installation. A second Starbucks was added when the new town center opened in 2008. (US Army photograph by Ken Drylie.)

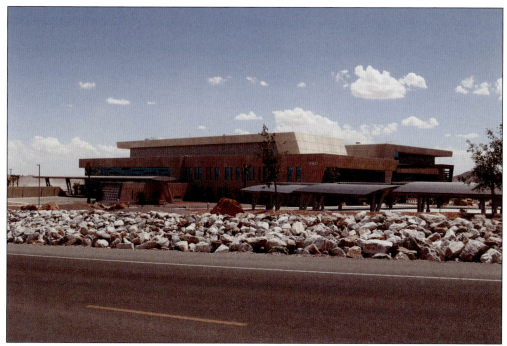

The new Weed Army Community Hospital opened in September 2017. The facility has its own power generation station, solar panels, and water purification facility. (US Army photograph by Ken Drylie.)

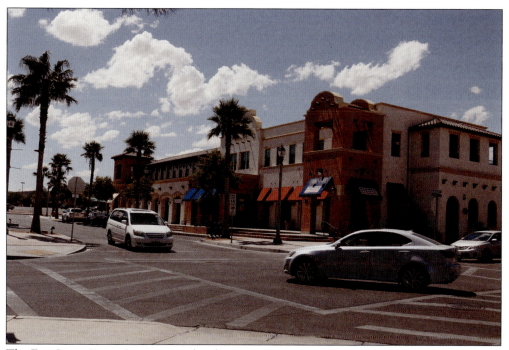

The Fort Irwin Town Center, completed in 2008, features retail shops on the ground level and single-soldier apartments on the second level. (US Army photograph by Ken Drylie.)

Discover Thousands of Local History Books
Featuring Millions of Vintage Images

Arcadia Publishing, the leading local history publisher in the United States, is committed to making history accessible and meaningful through publishing books that celebrate and preserve the heritage of America's people and places.

Find more books like this at
www.arcadiapublishing.com

Search for your hometown history, your old stomping grounds, and even your favorite sports team.

Consistent with our mission to preserve history on a local level, this book was printed in South Carolina on American-made paper and manufactured entirely in the United States. Products carrying the accredited Forest Stewardship Council (FSC) label are printed on 100 percent FSC-certified paper.